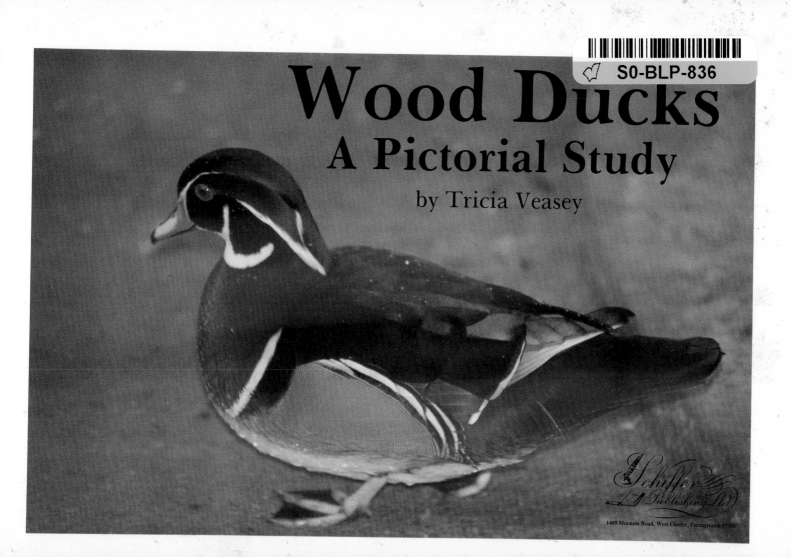

Wood Ducks
A Pictorial Study

by Tricia Veasey

Schiffer Publishing Ltd

1469 Morstein Road, West Chester, Pennsylvania 19380

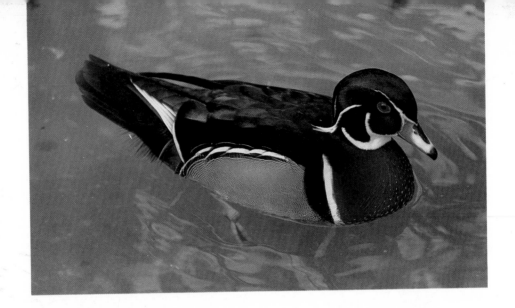

Printed in the United States of America.
ISBN: 0-88740-155-4
Published by Schiffer Publishing Ltd.
1469 Morstein Road, West Chester, Pennsylvania 19380

This book may be purchased from the publisher.
Please include $2.00 postage.
Try your bookstore first.

Other books from Tricia Veasey

Canvasbacks, a pictorial study
Mallards, a pictorial study
Geese, a pictorial study
Championship Carving
Championship Carving-second volume
Waterfowl Illustrated

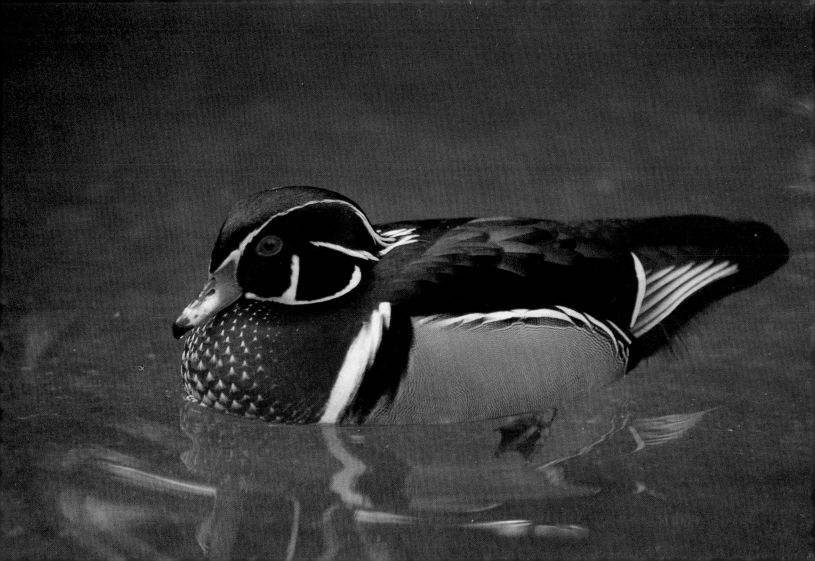

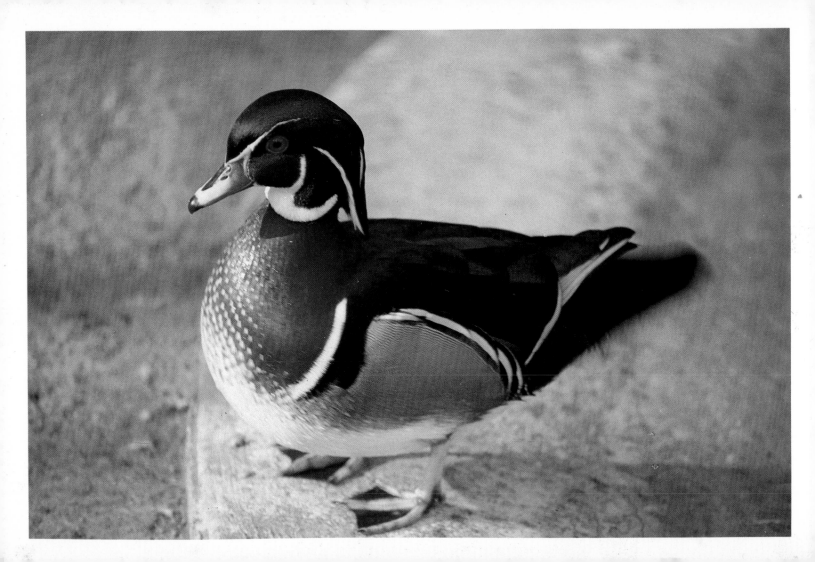

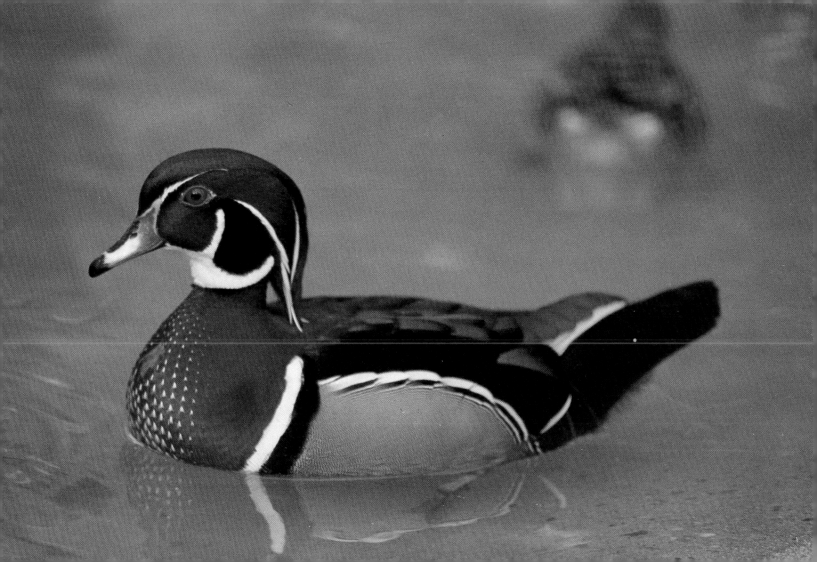

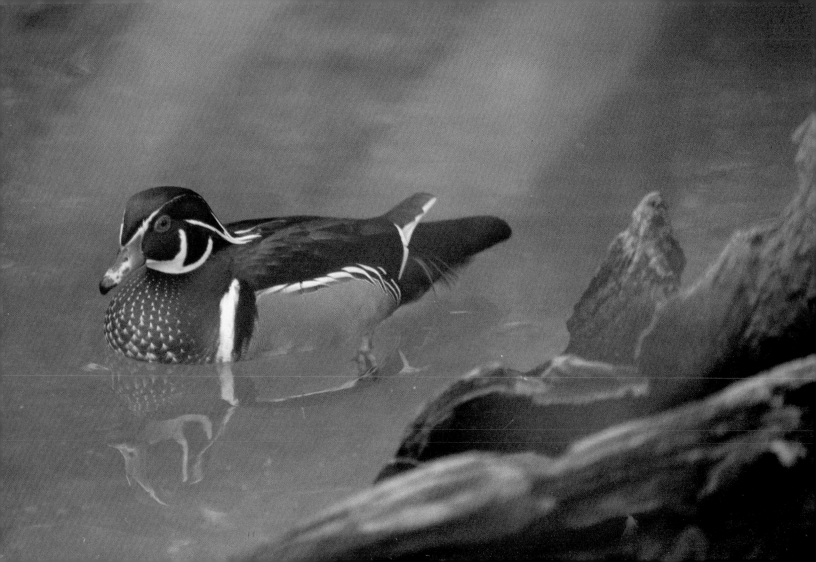

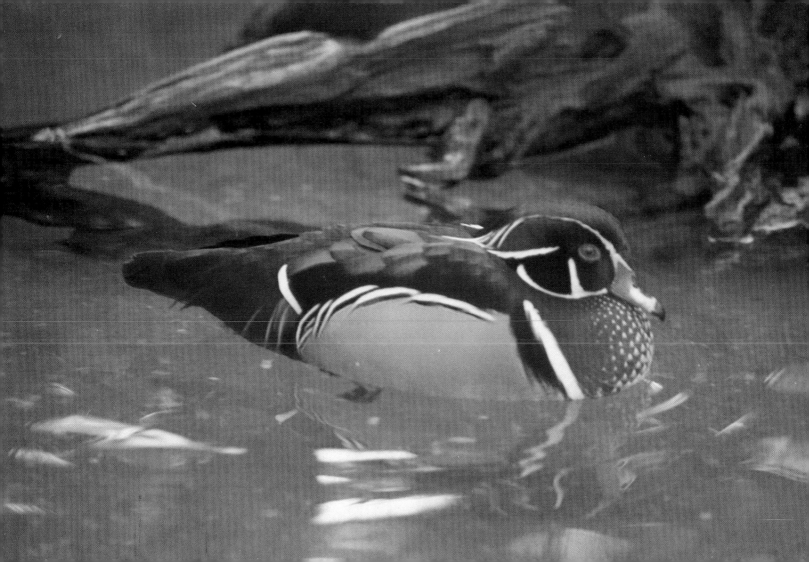

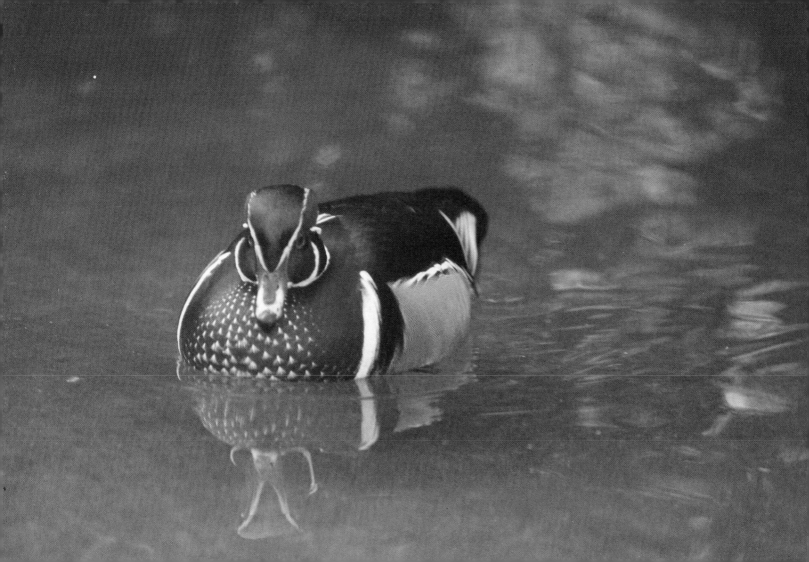

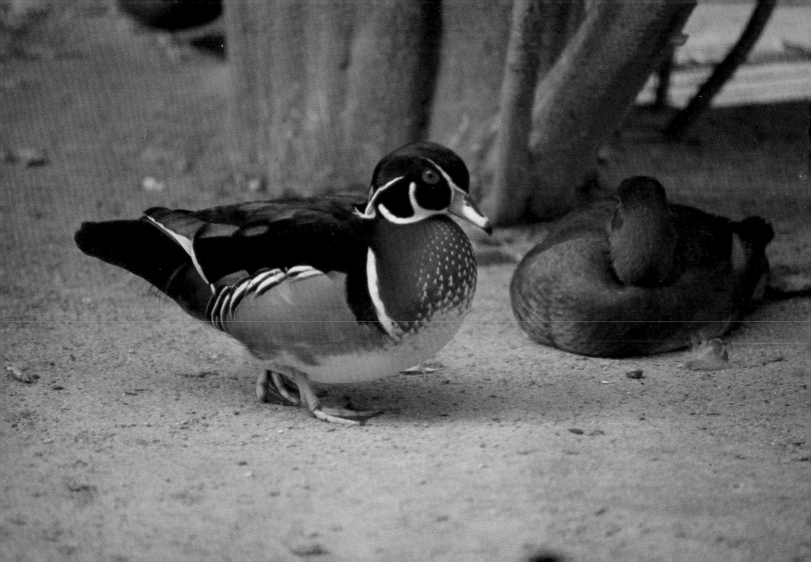

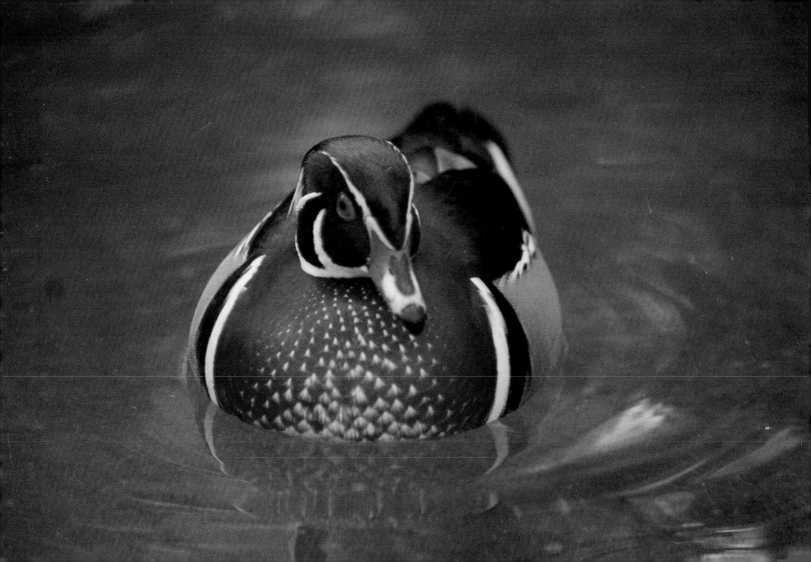

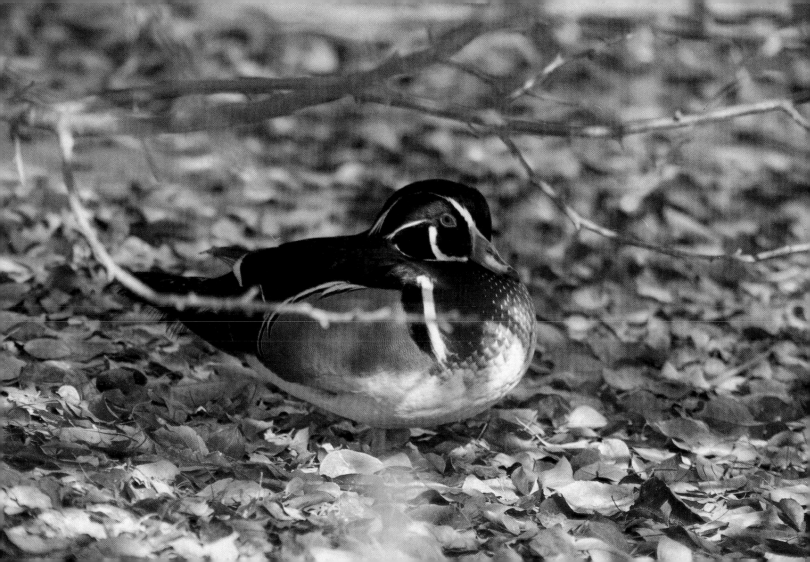

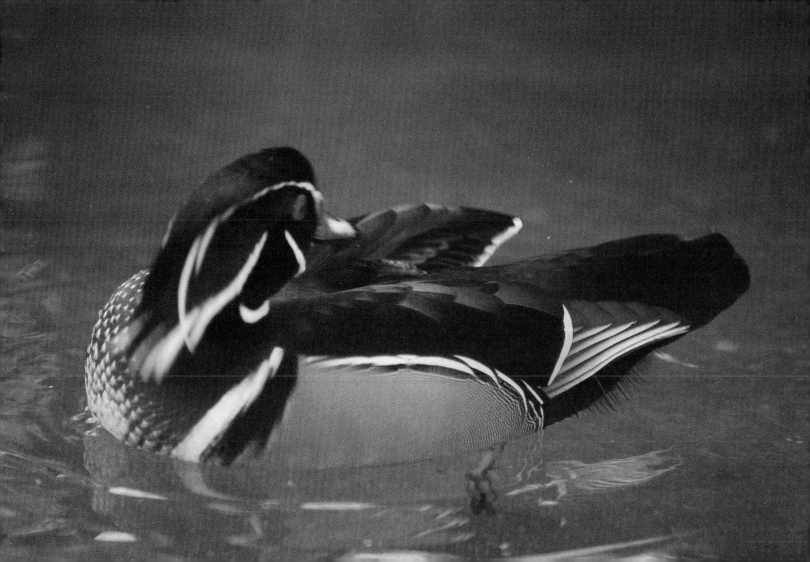

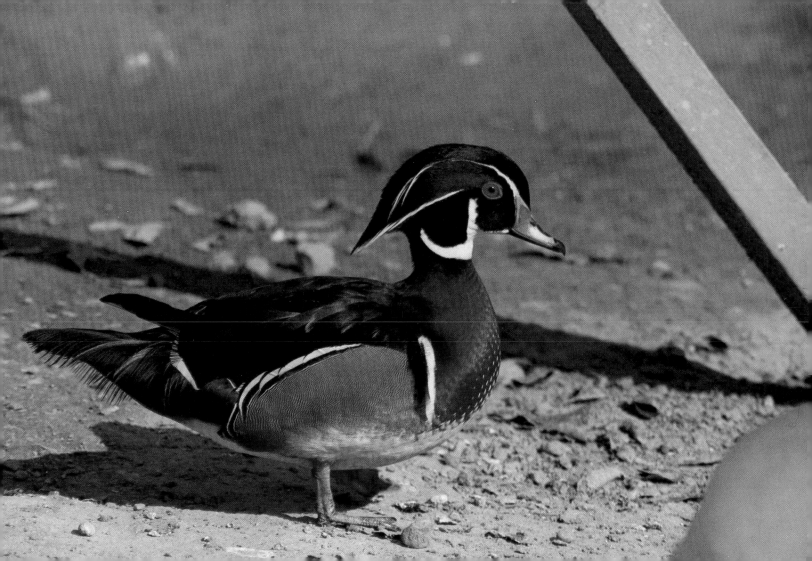

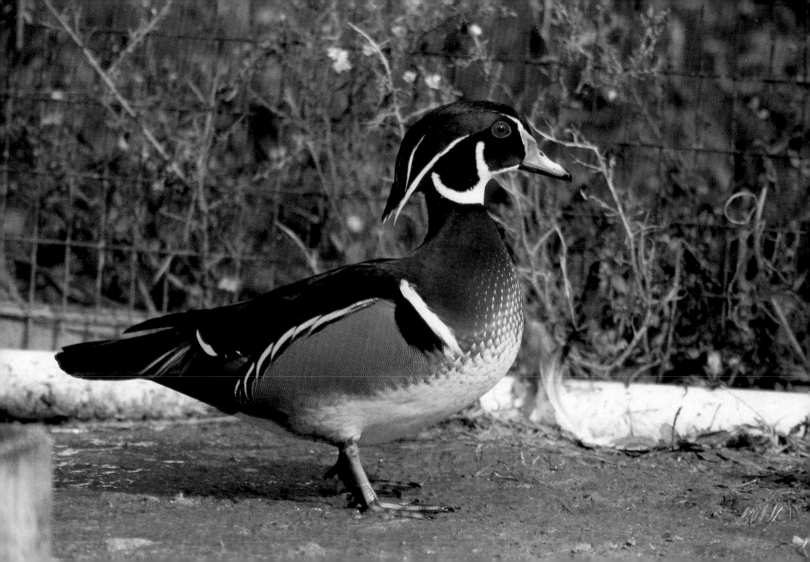

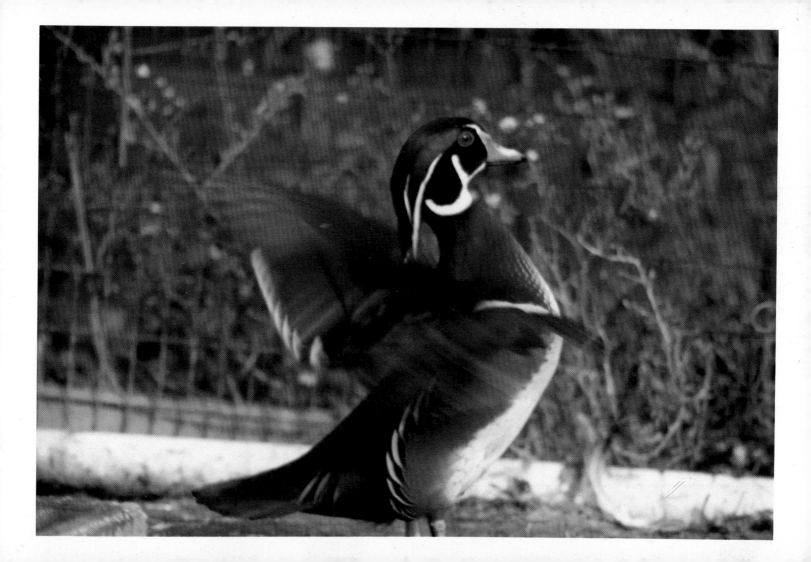

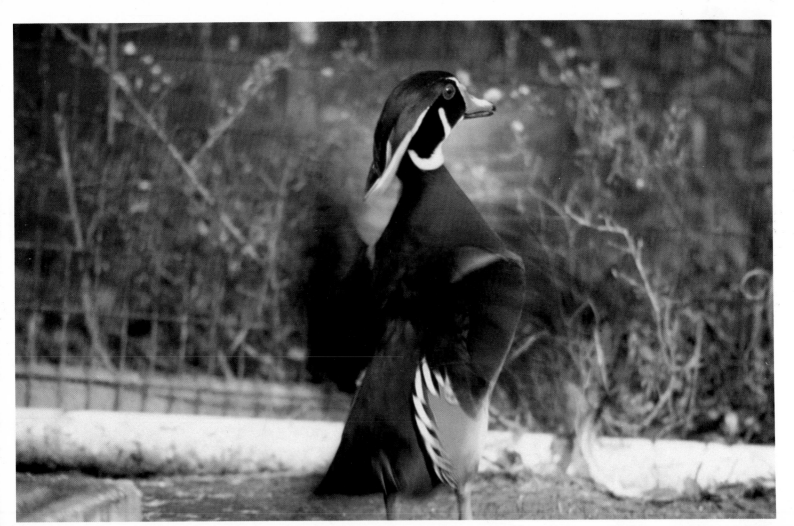

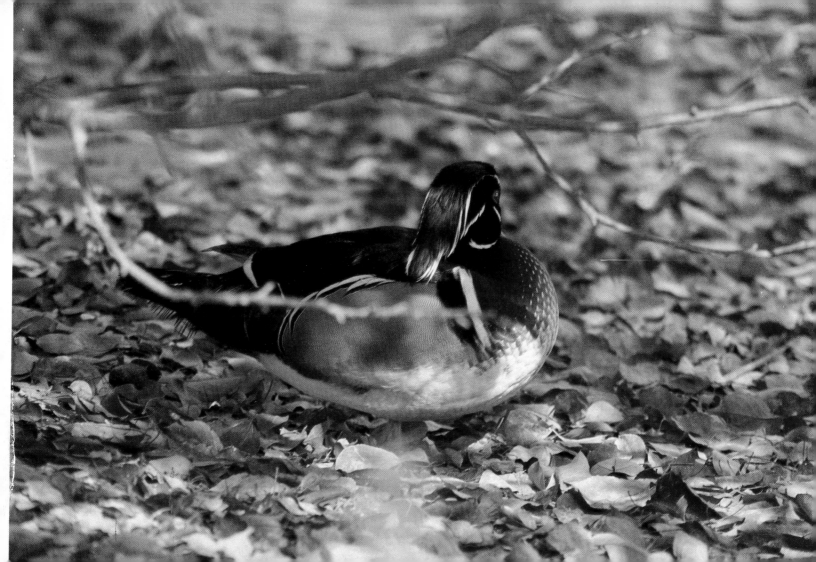

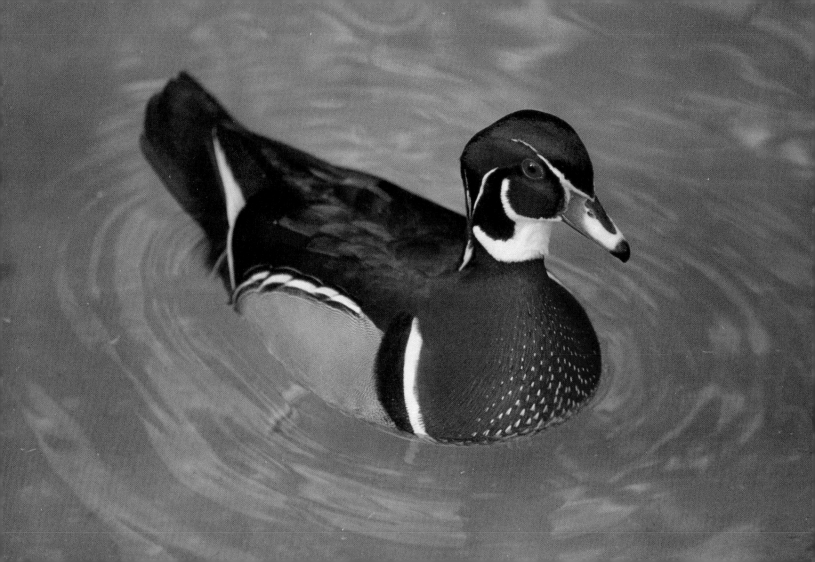

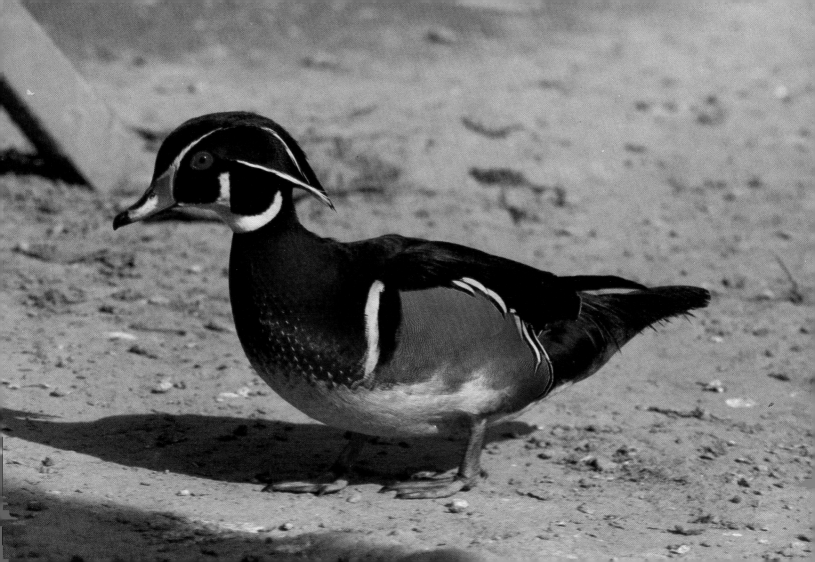

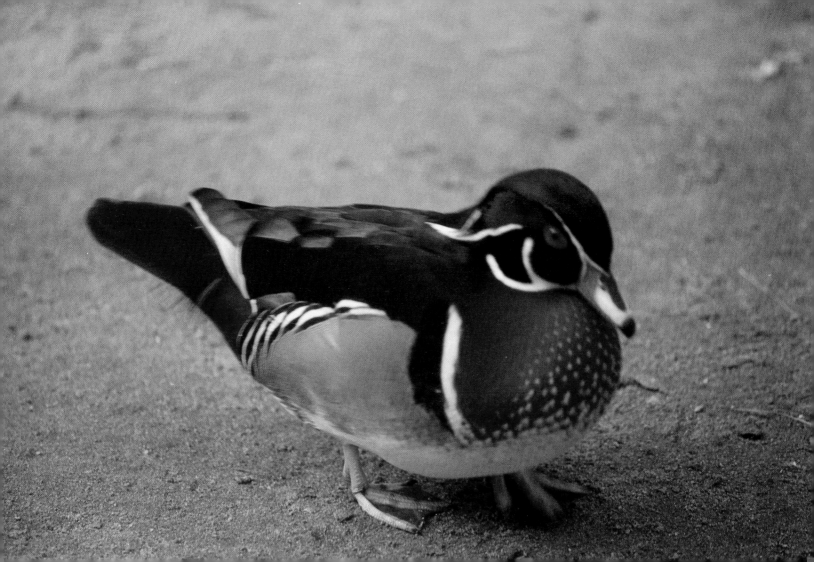

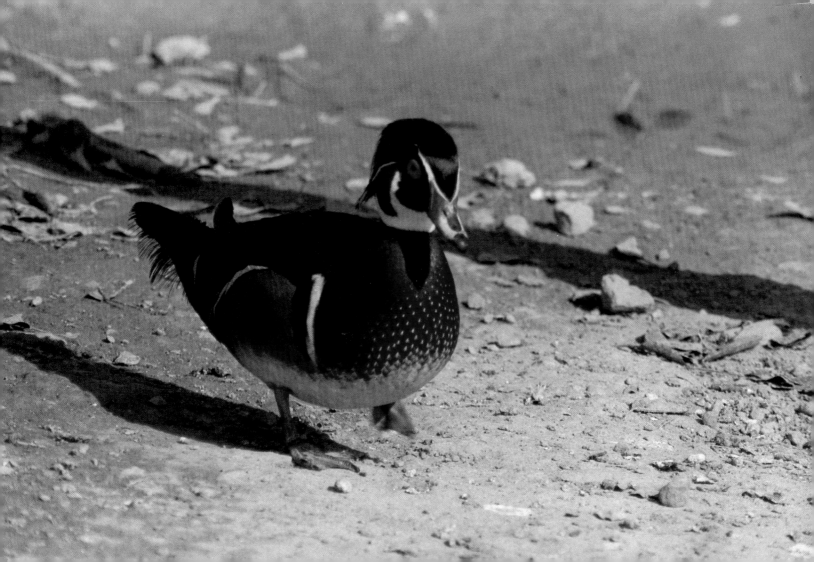

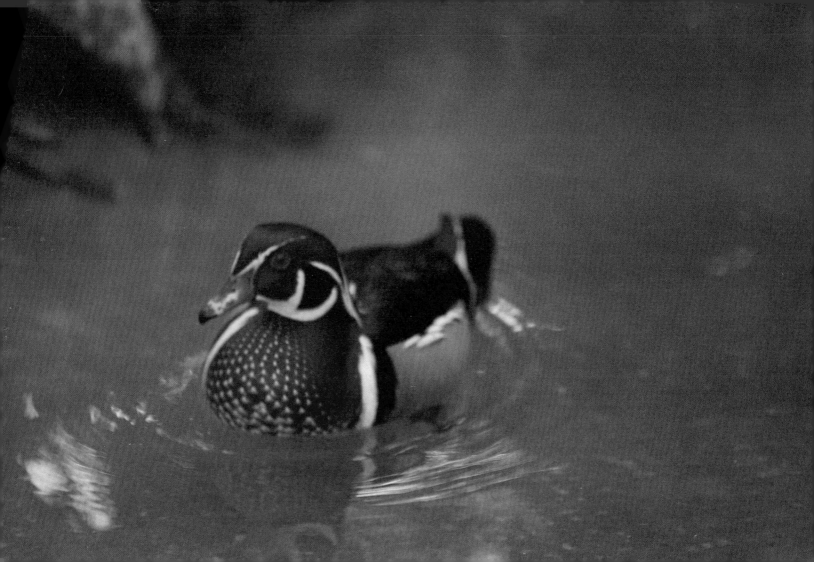

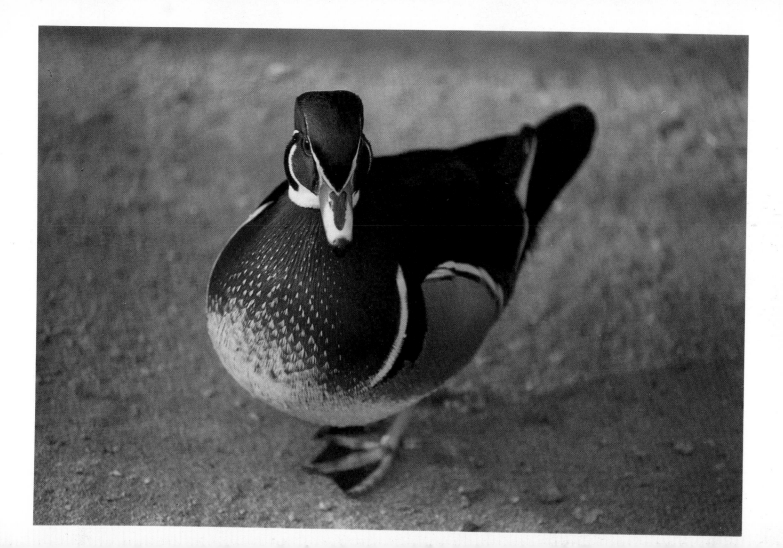

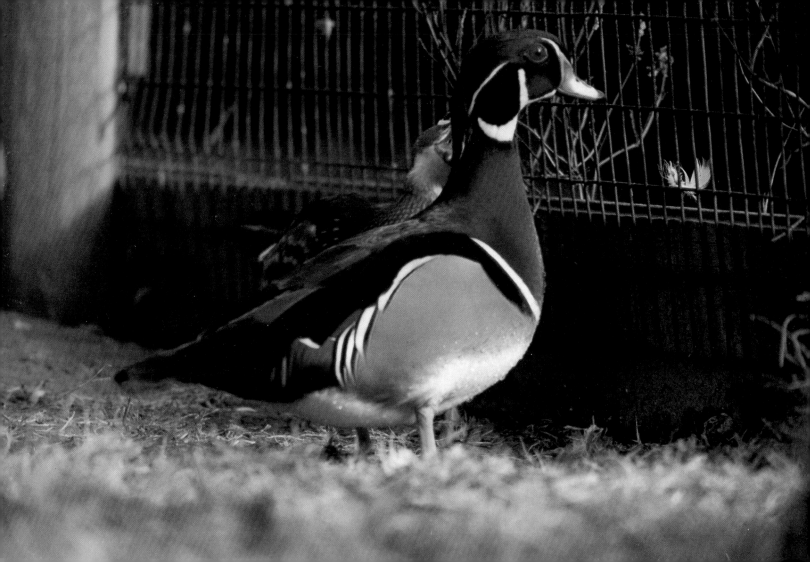

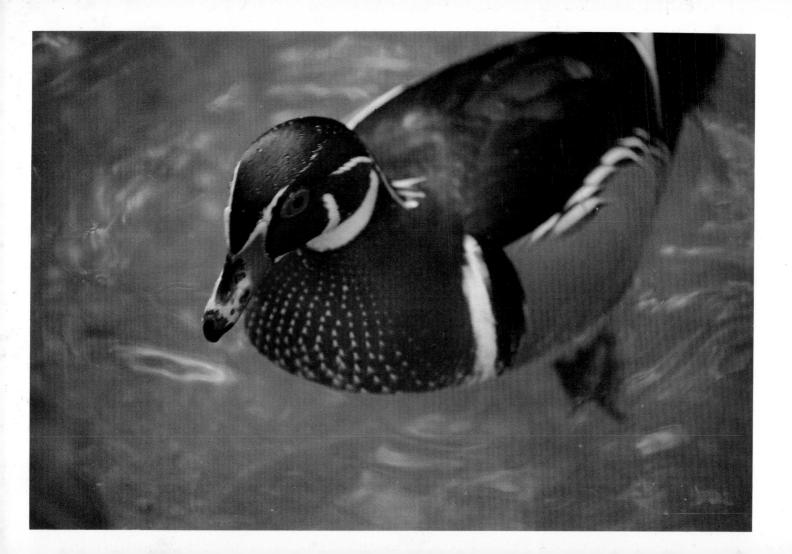

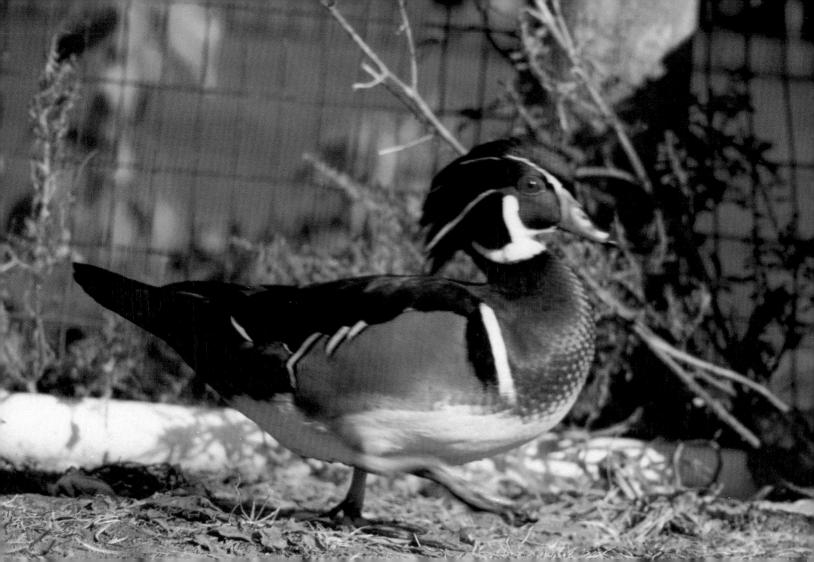

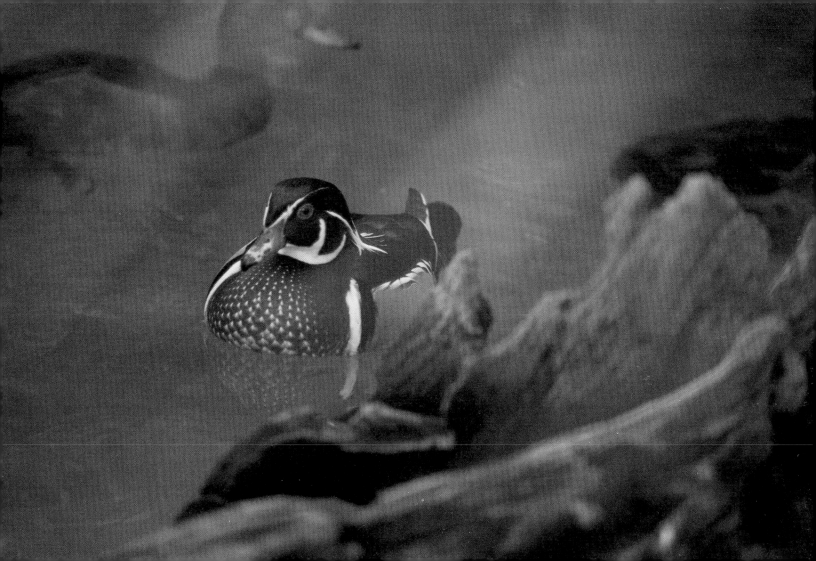

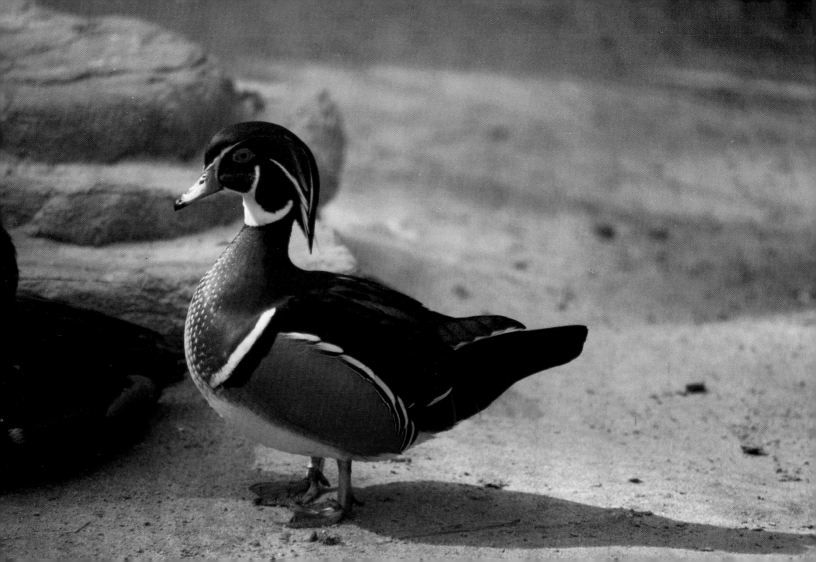

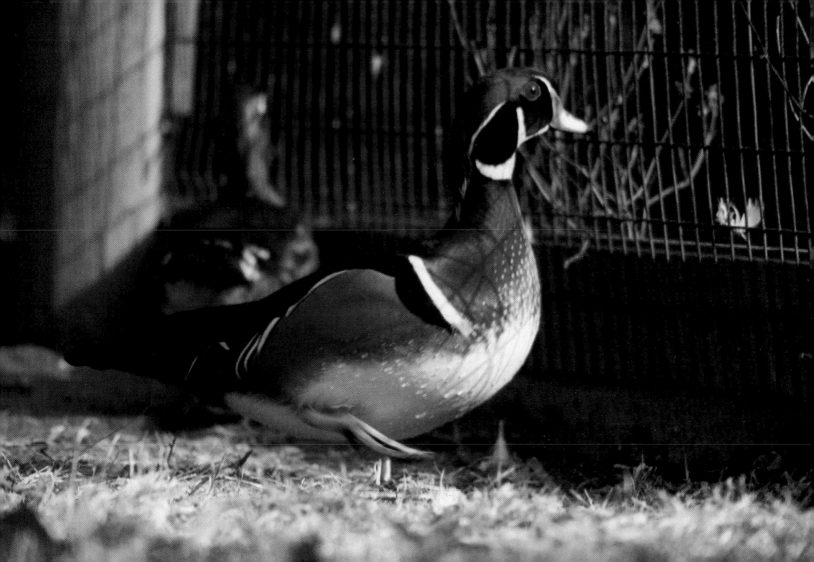

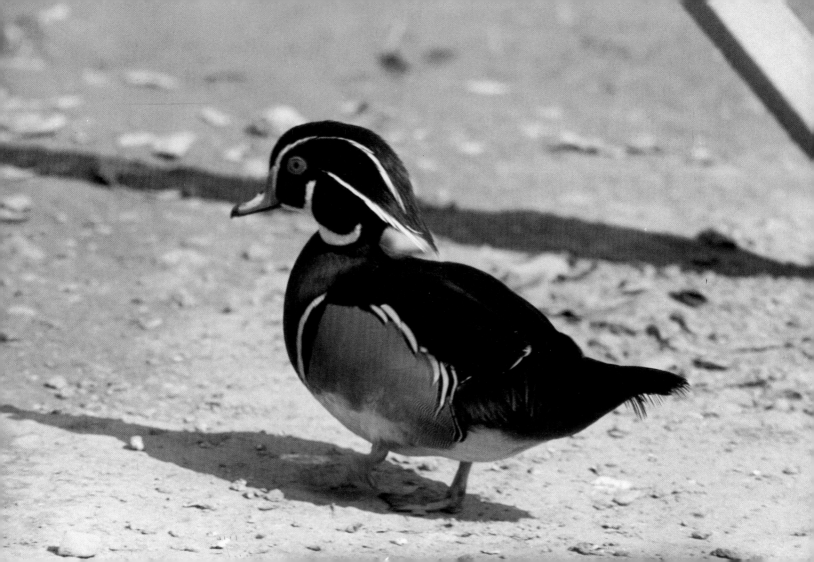

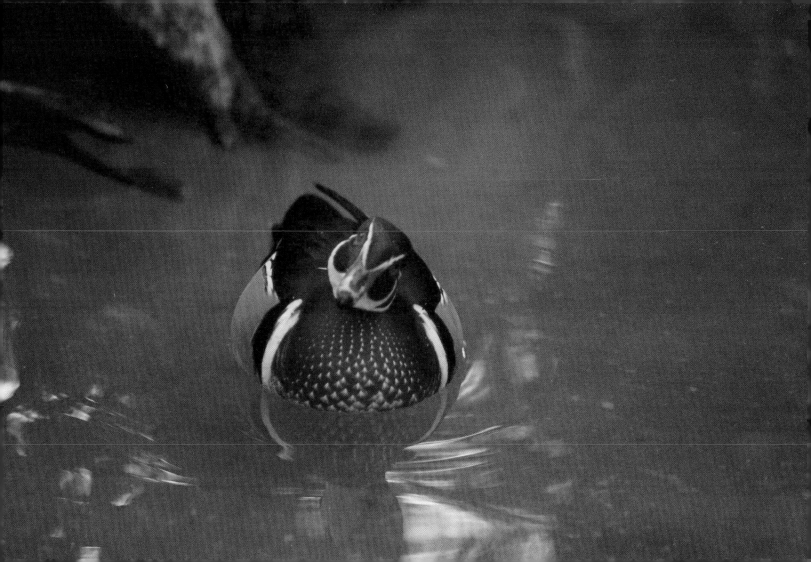

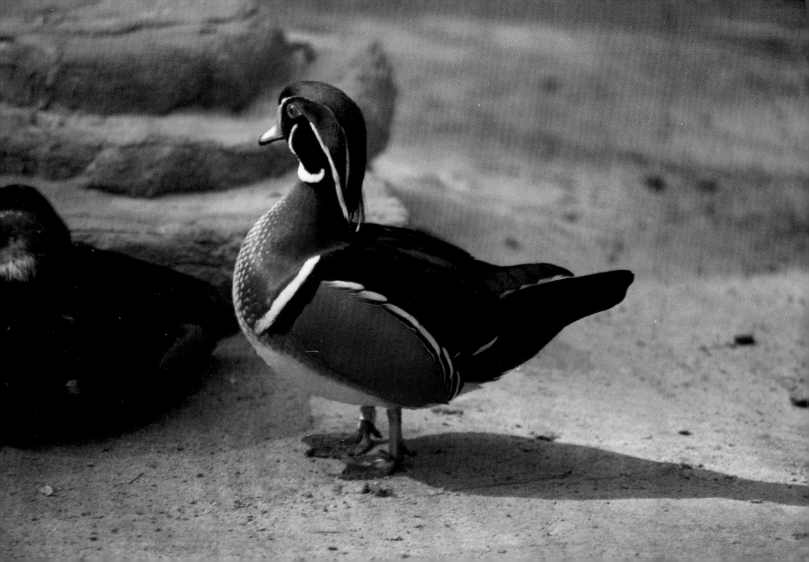

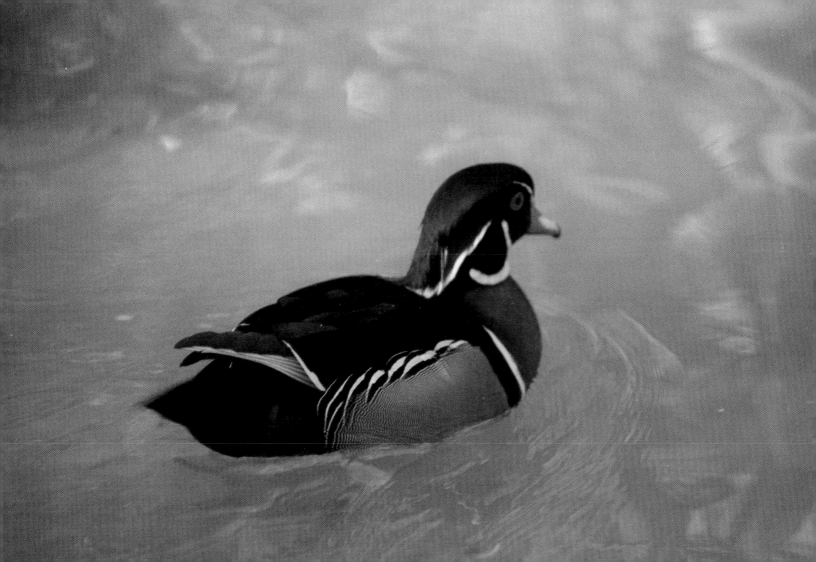

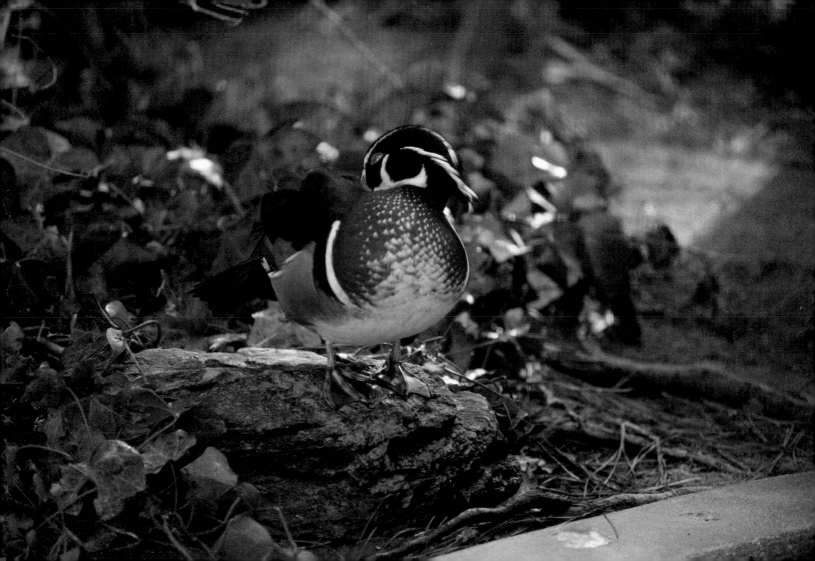

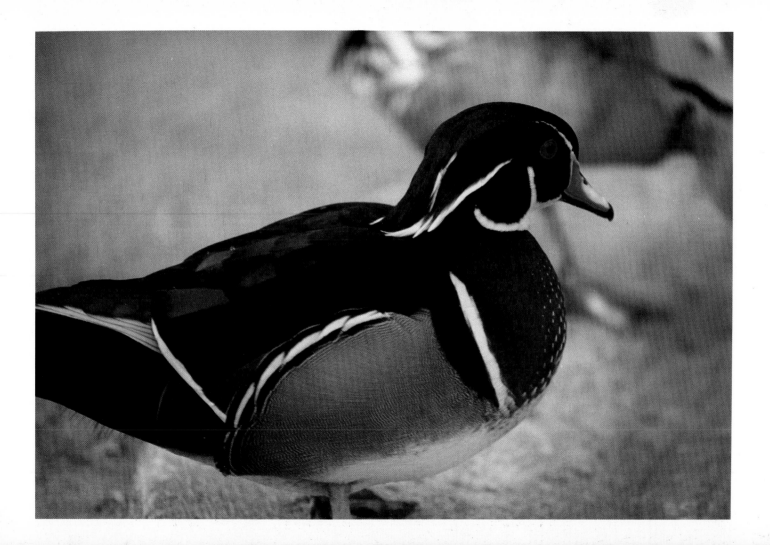

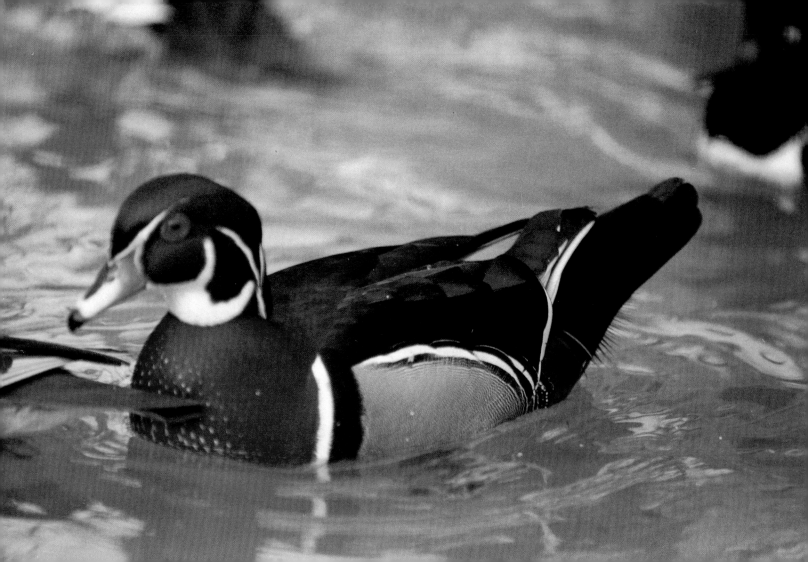

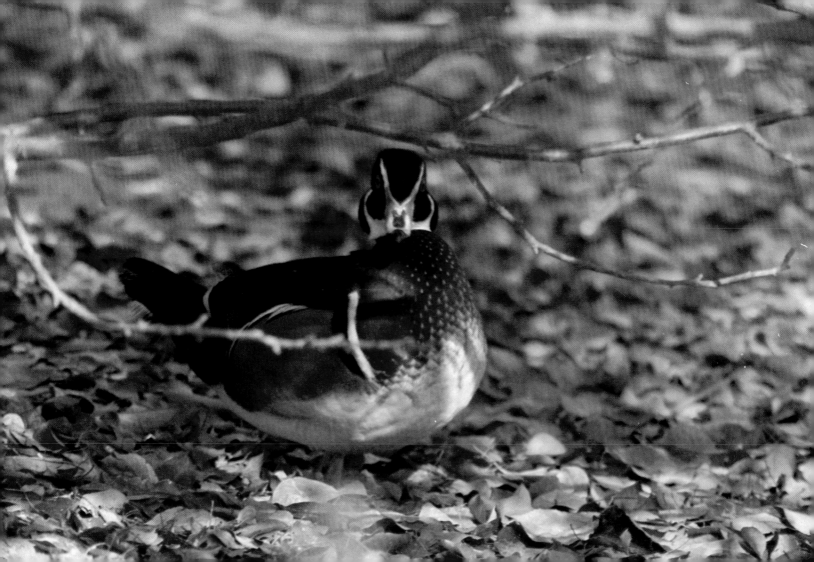

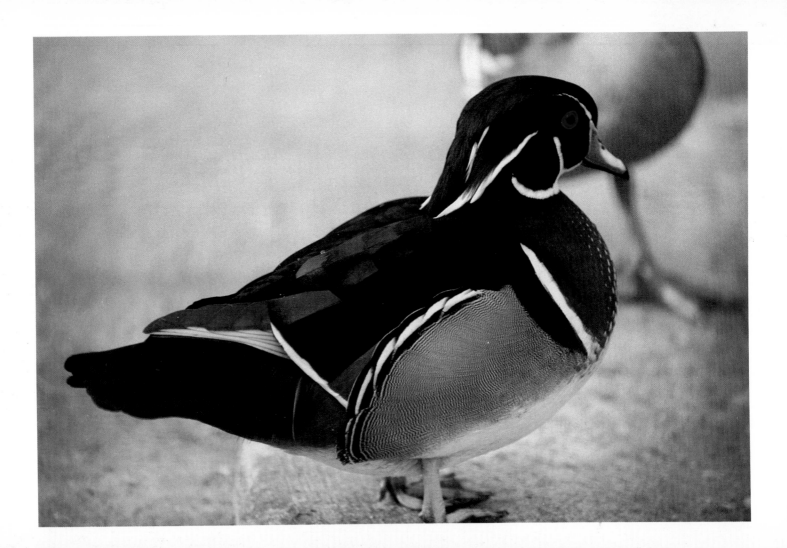

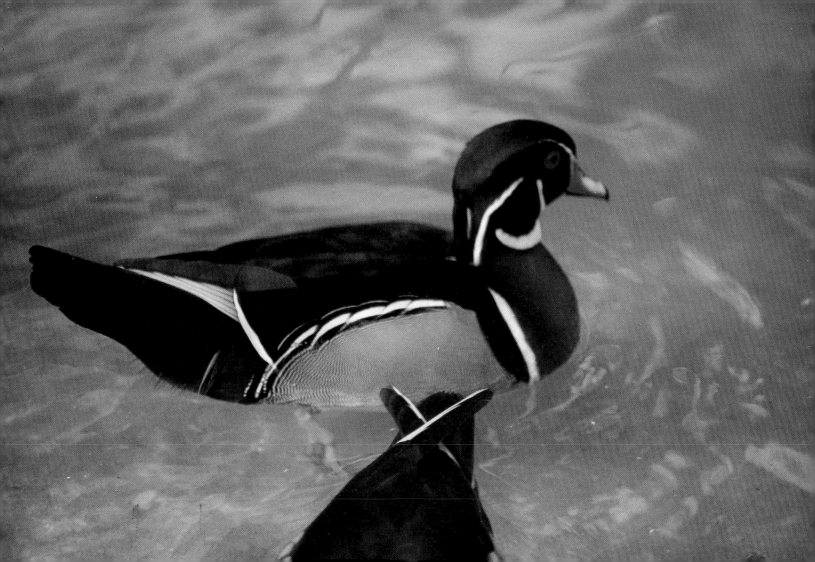

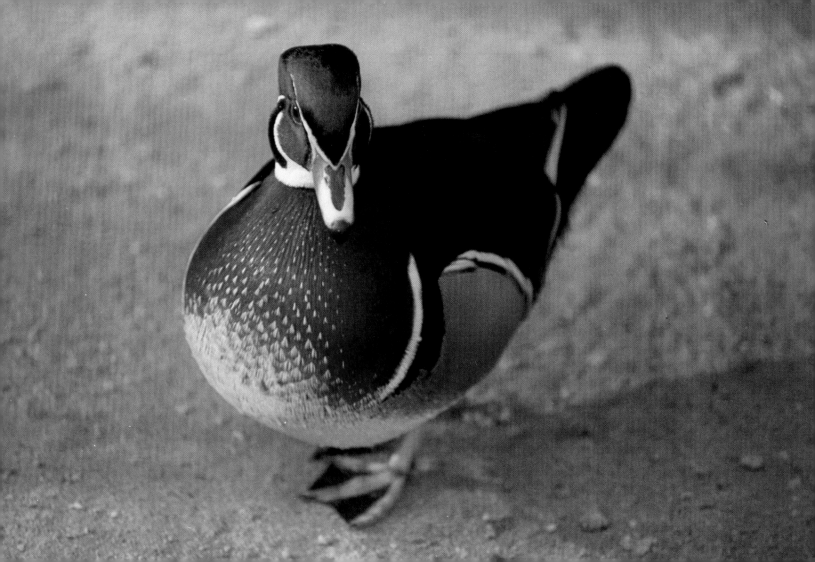

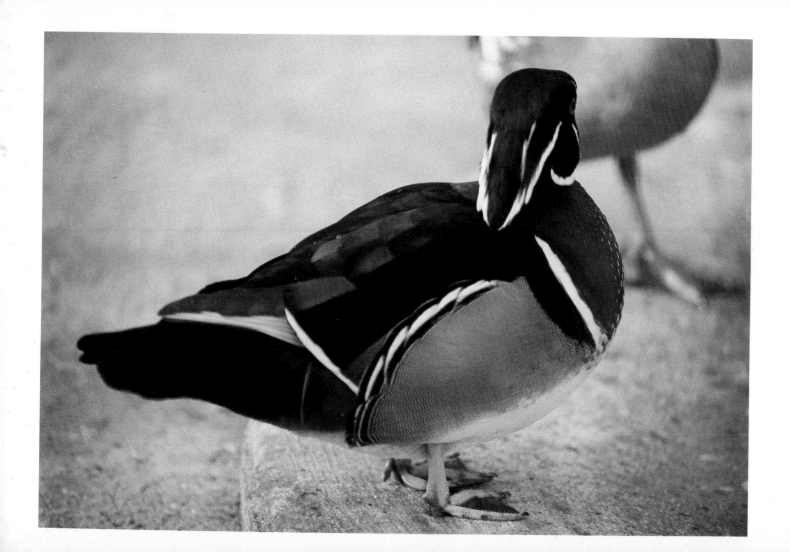

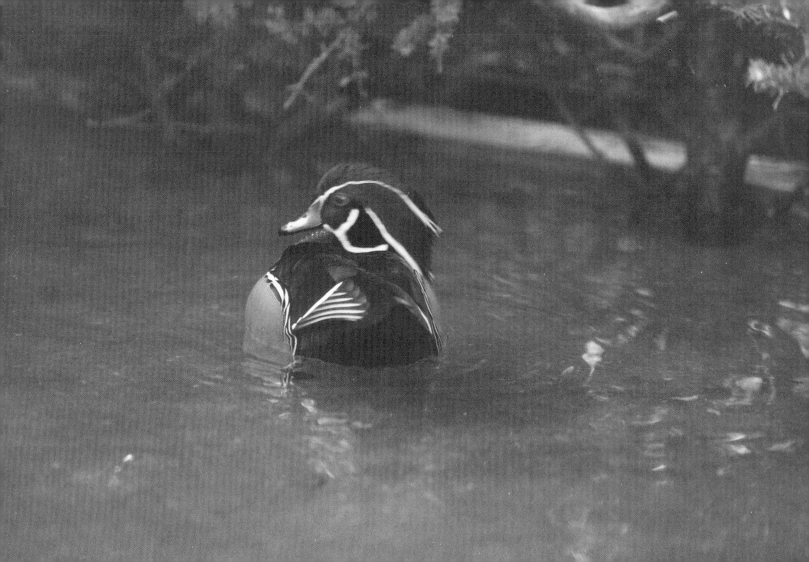

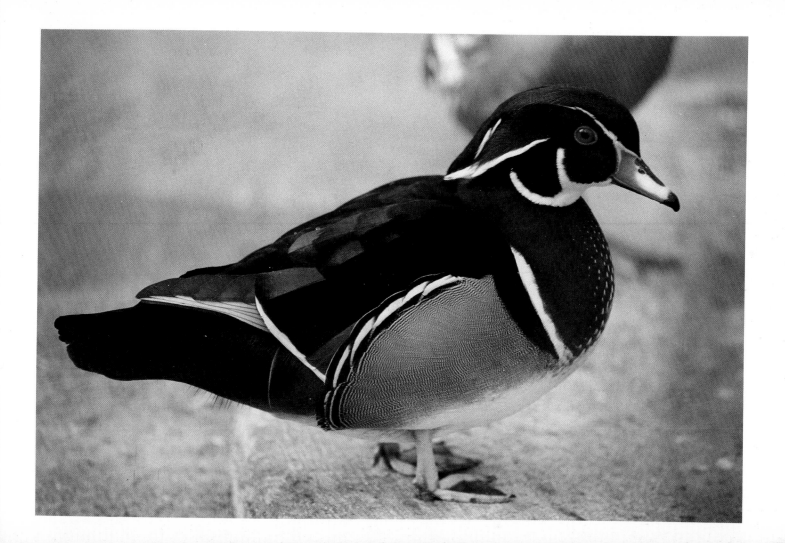

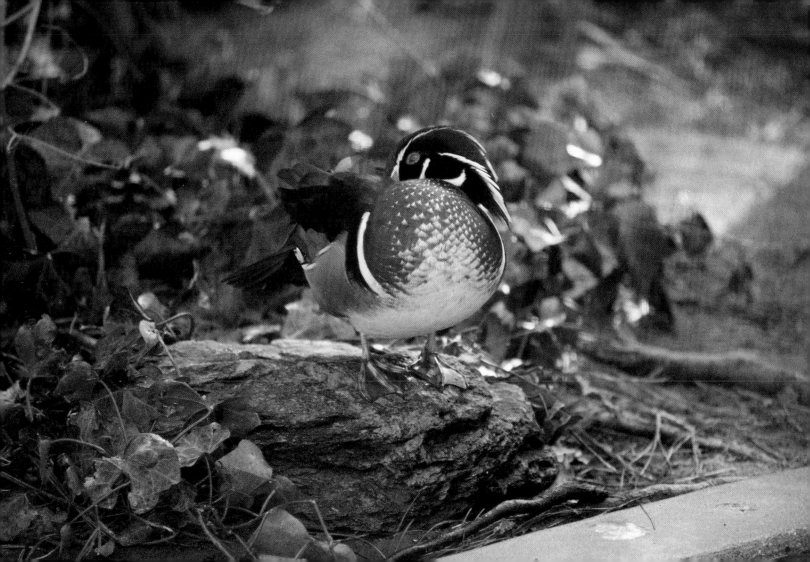

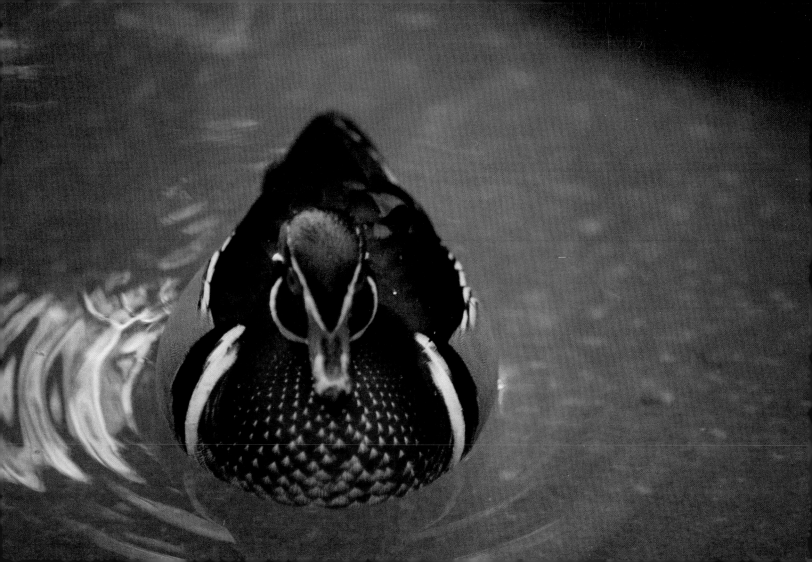

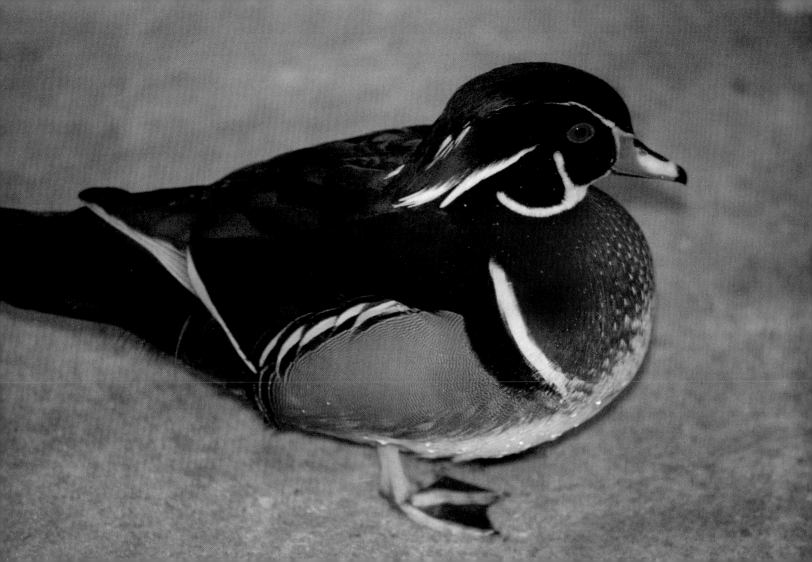

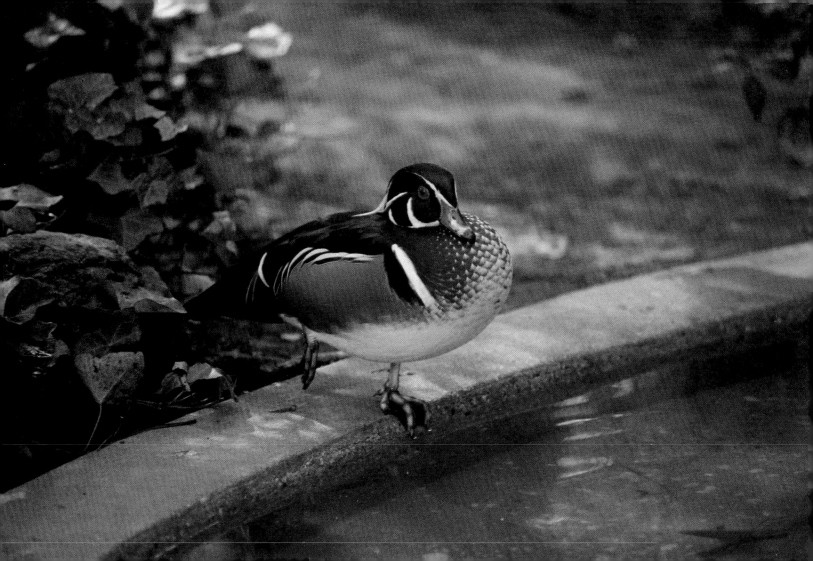

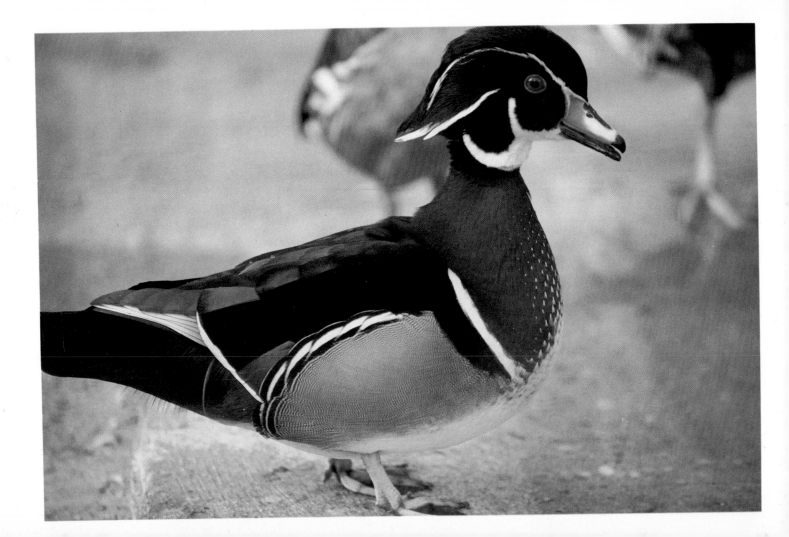

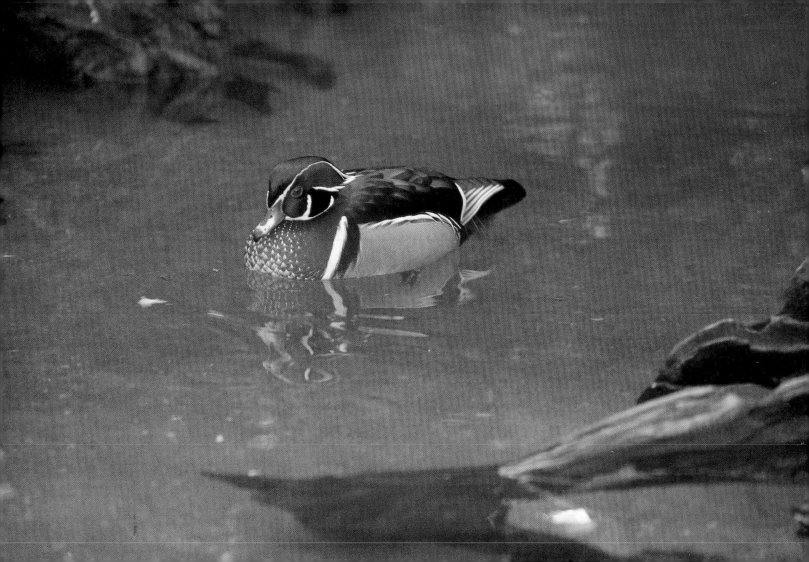

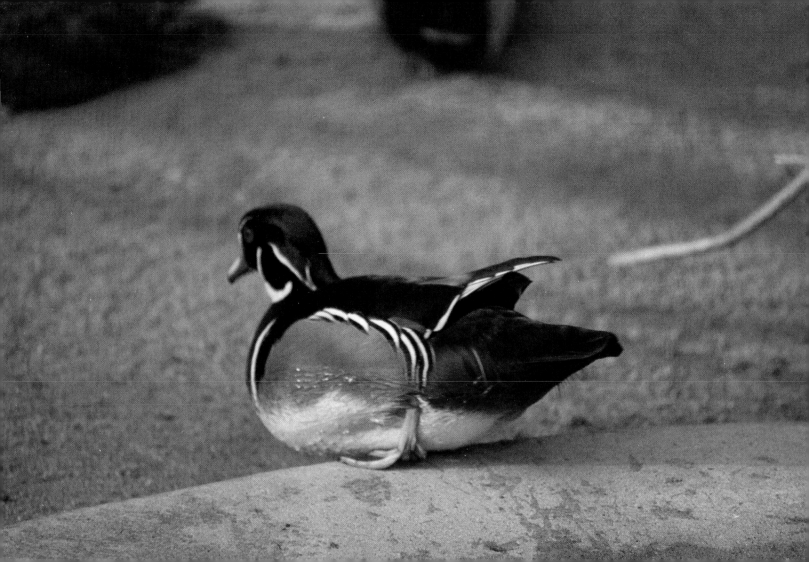

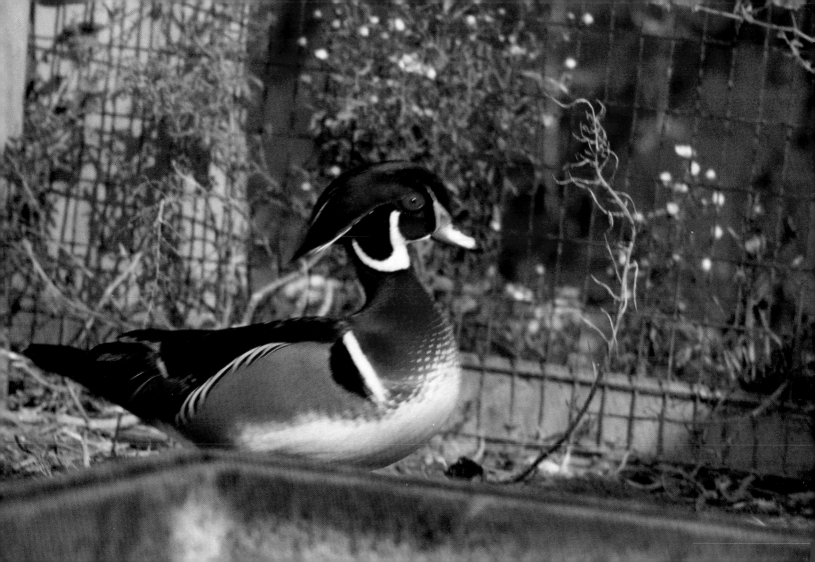

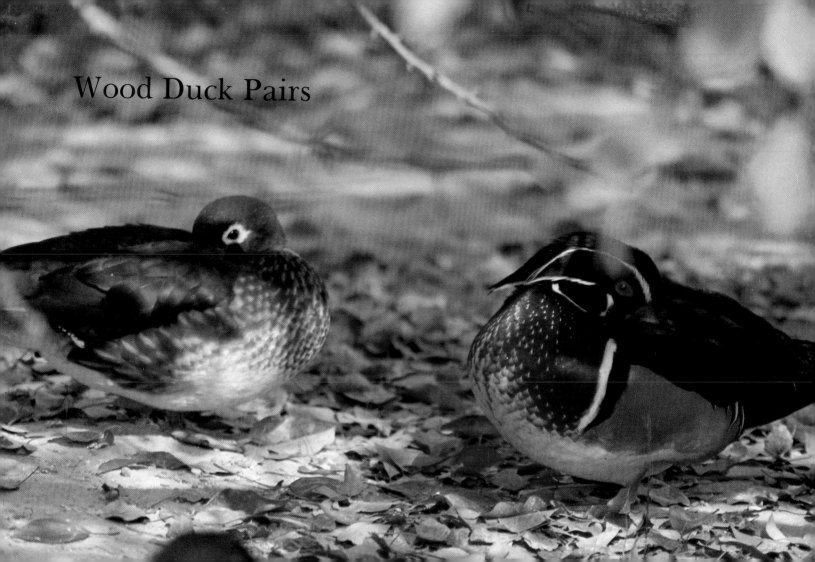

Wood Duck Pairs

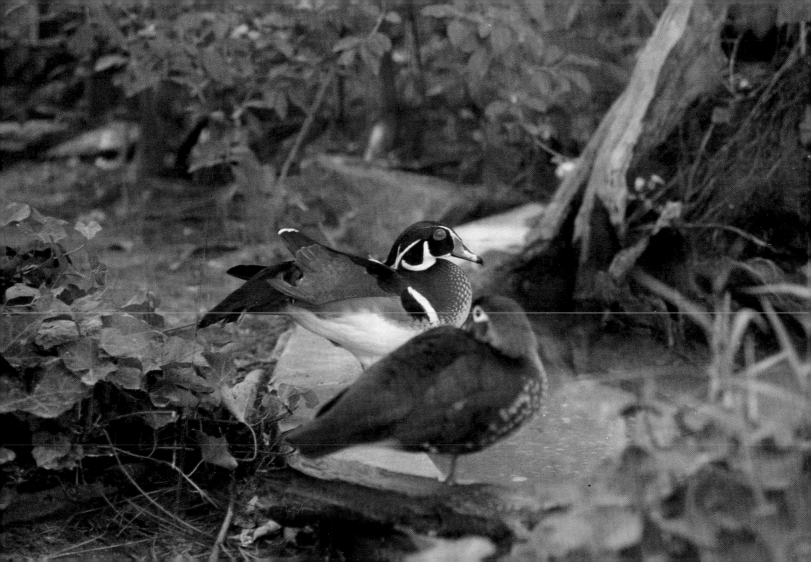

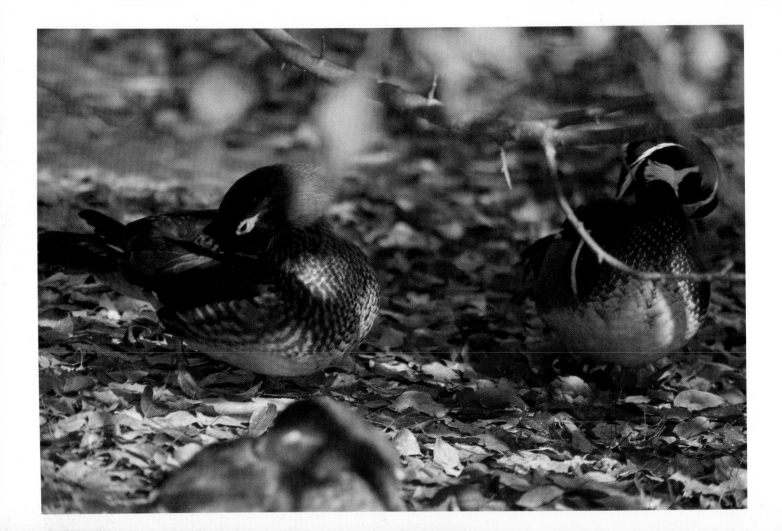

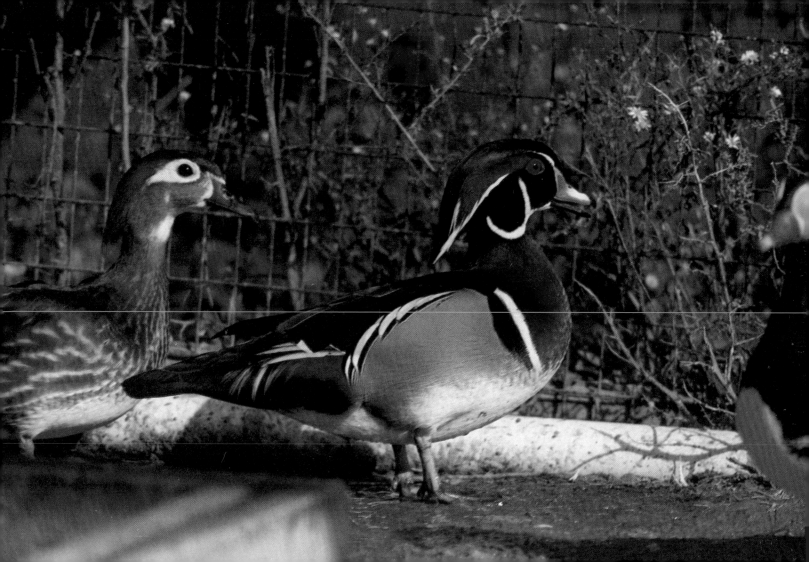

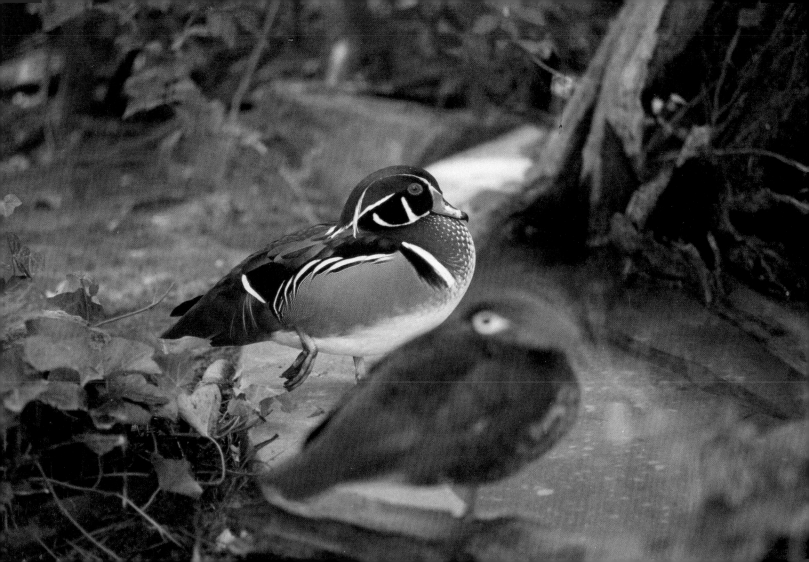

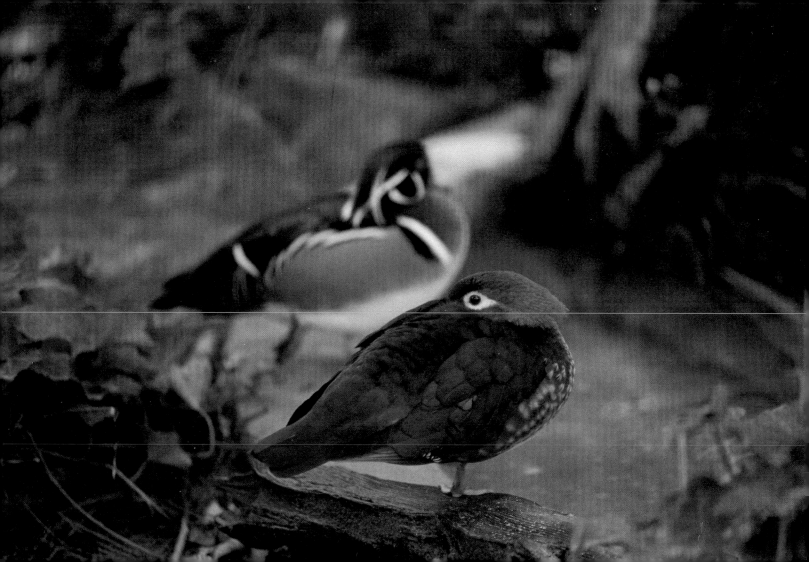

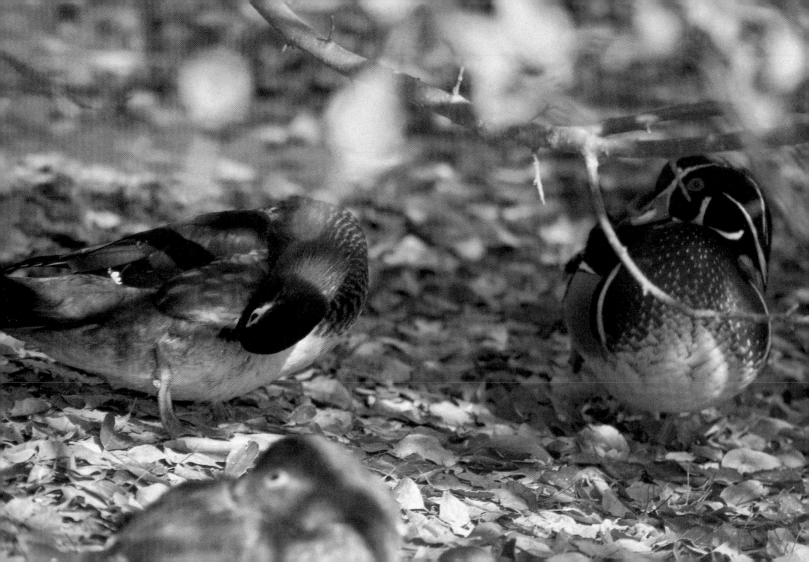

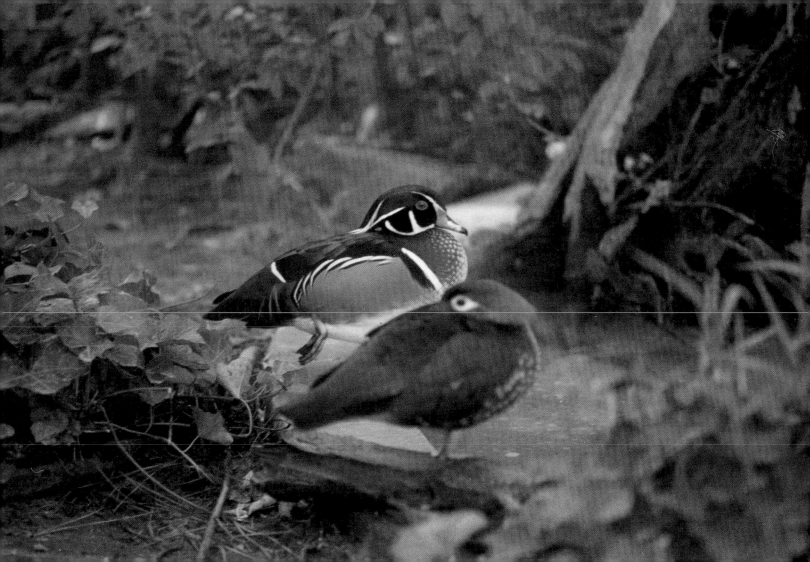

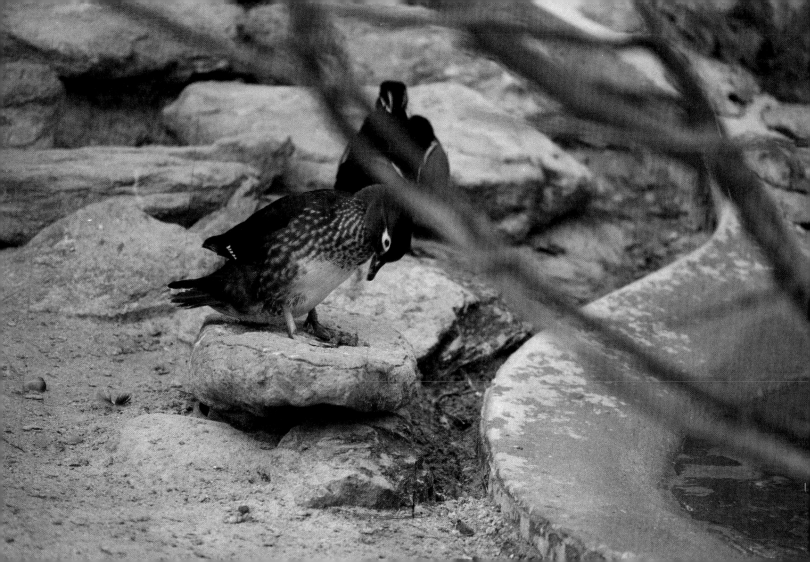

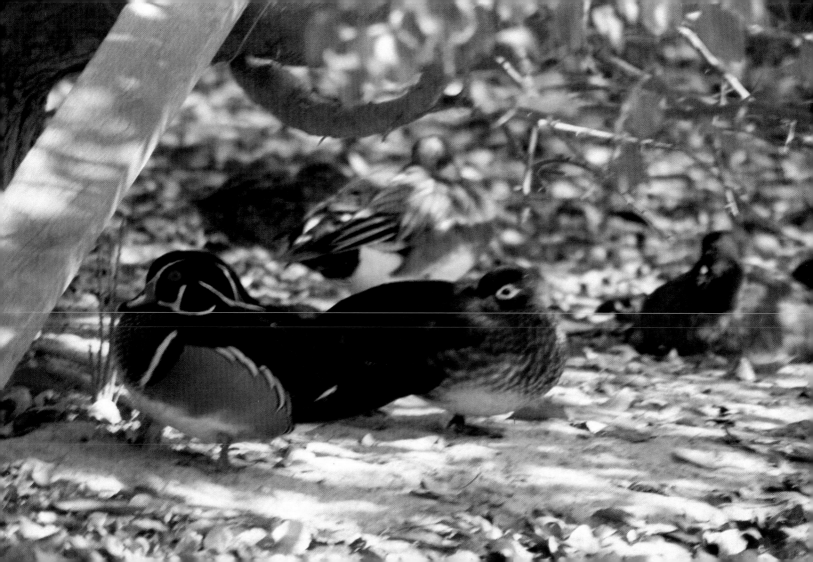

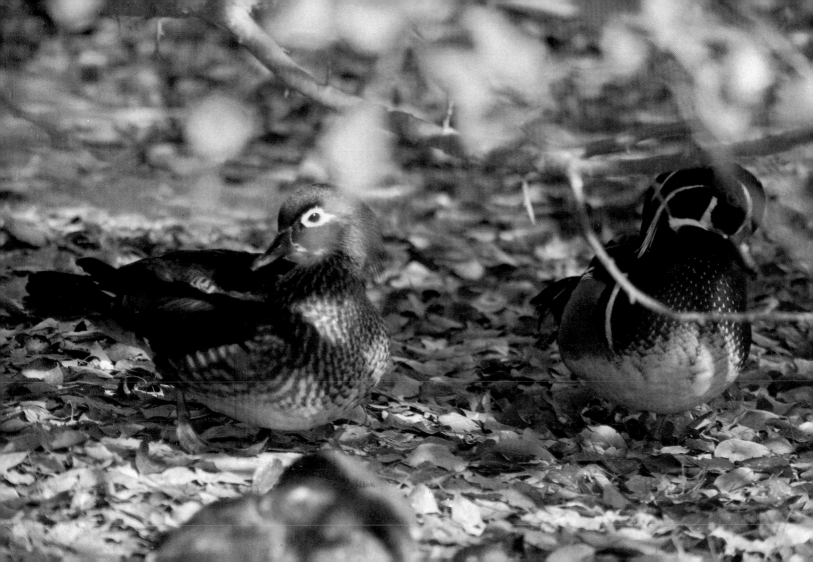

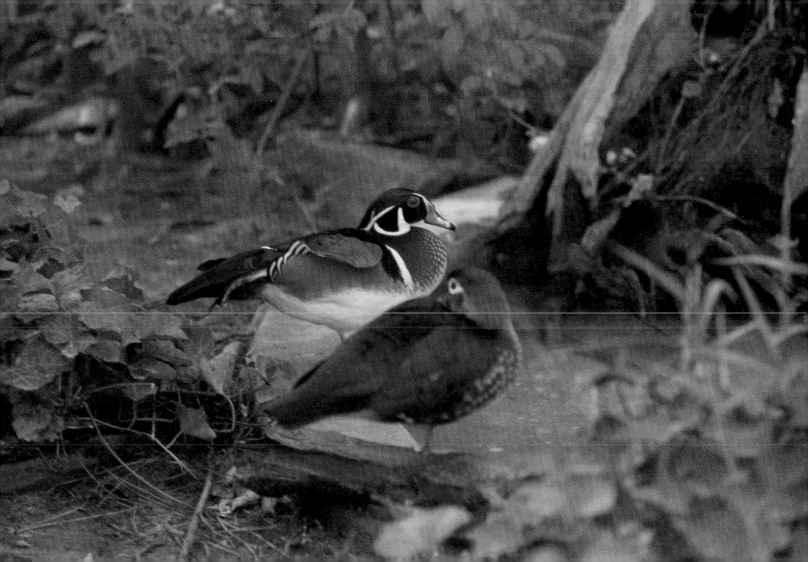

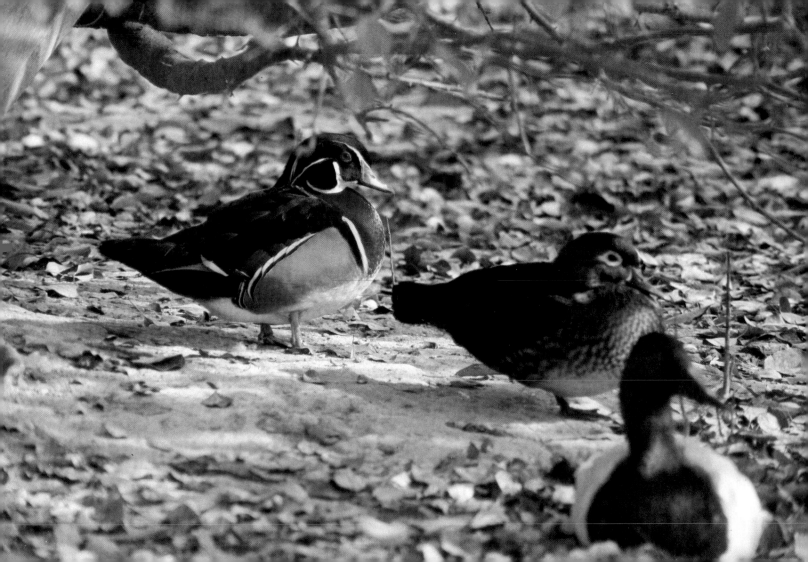

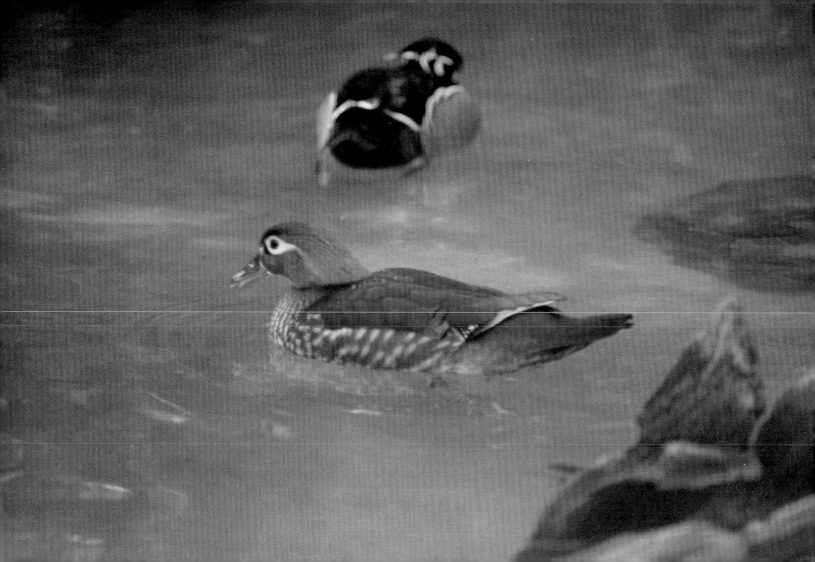

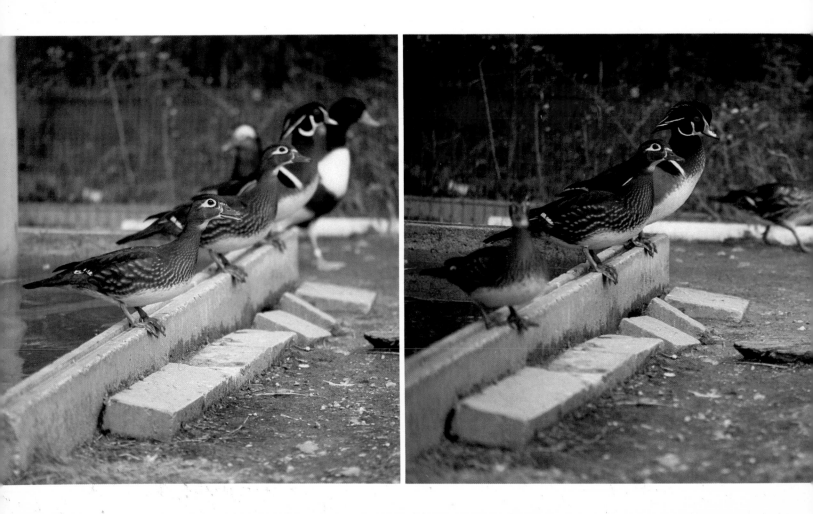

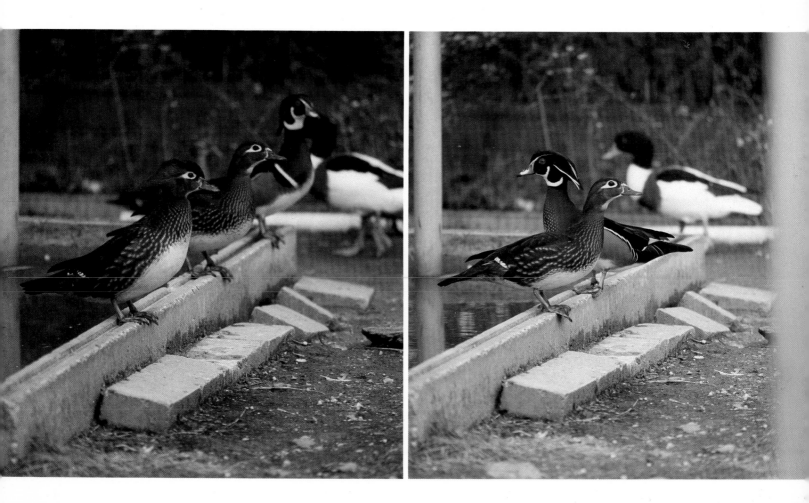

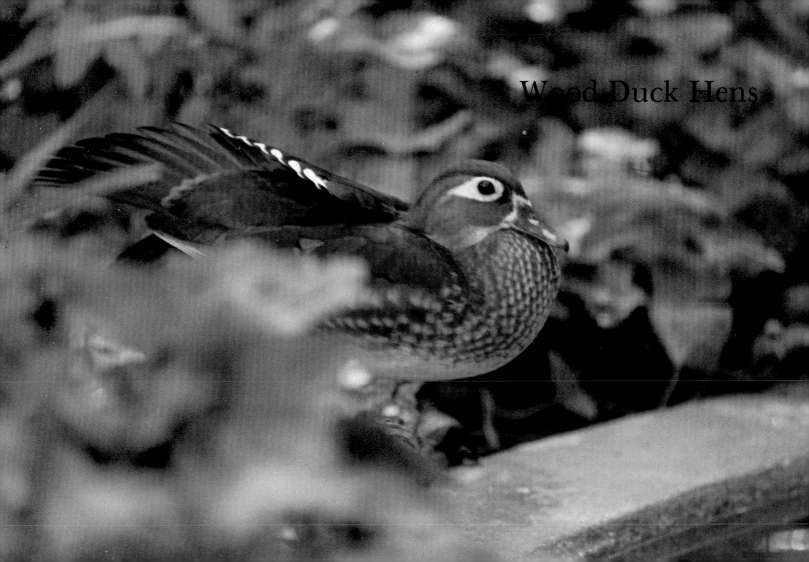

Wood Duck Hens

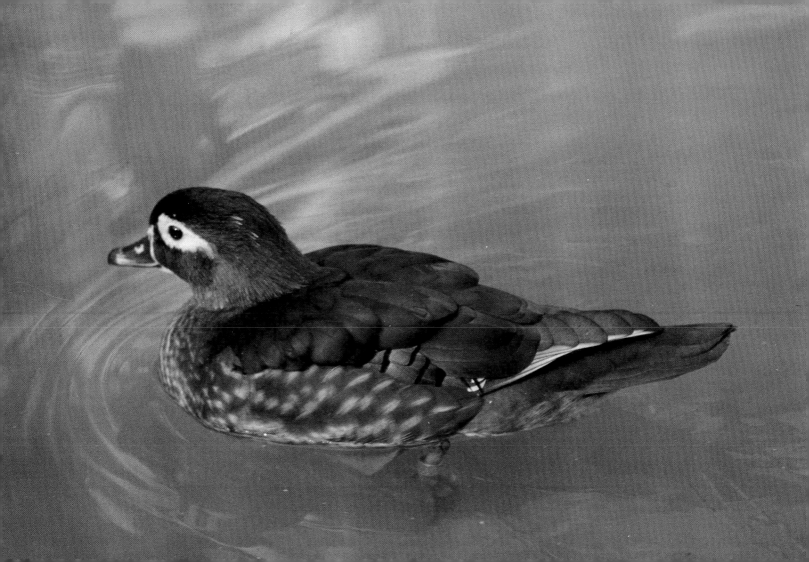

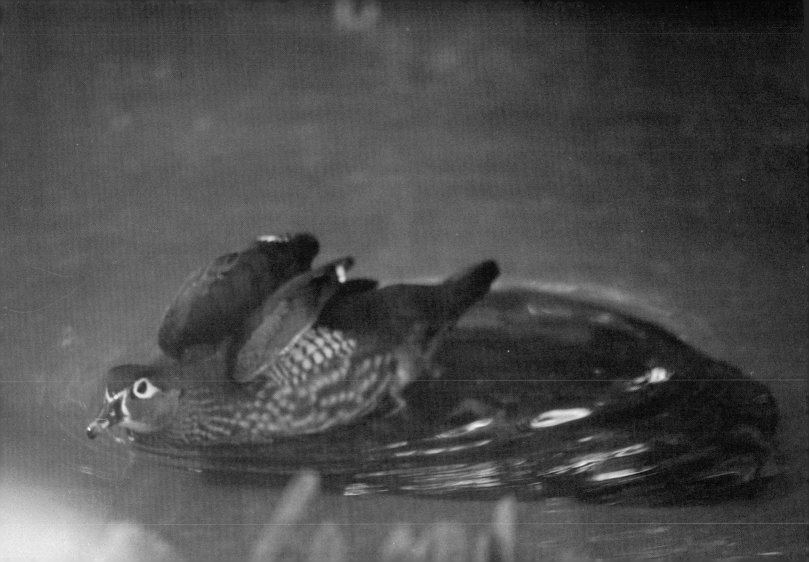

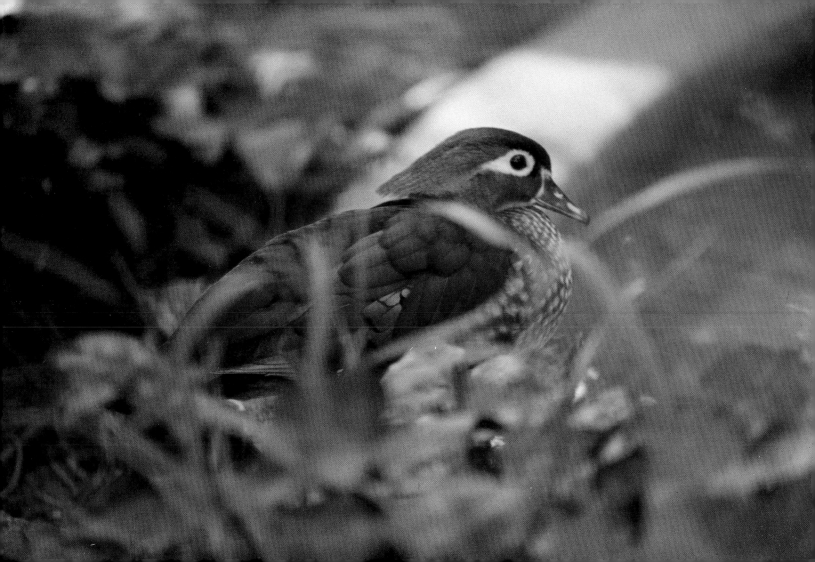

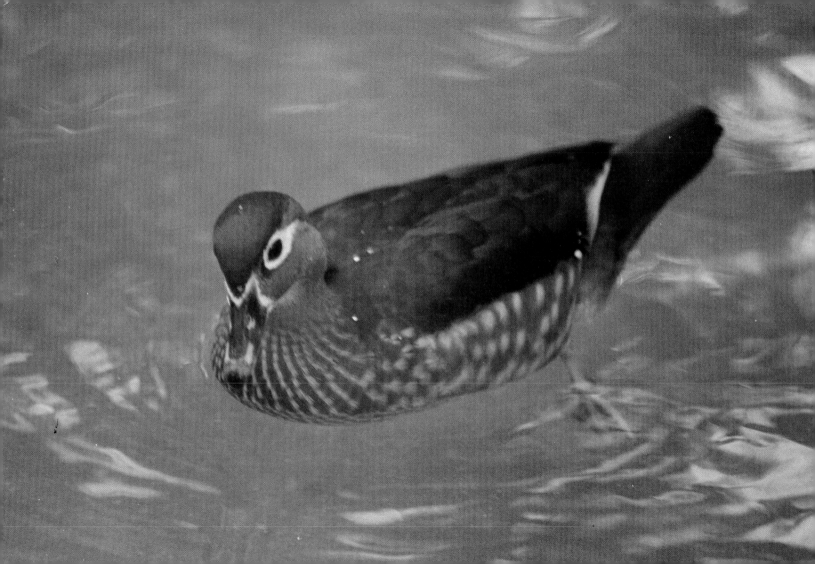

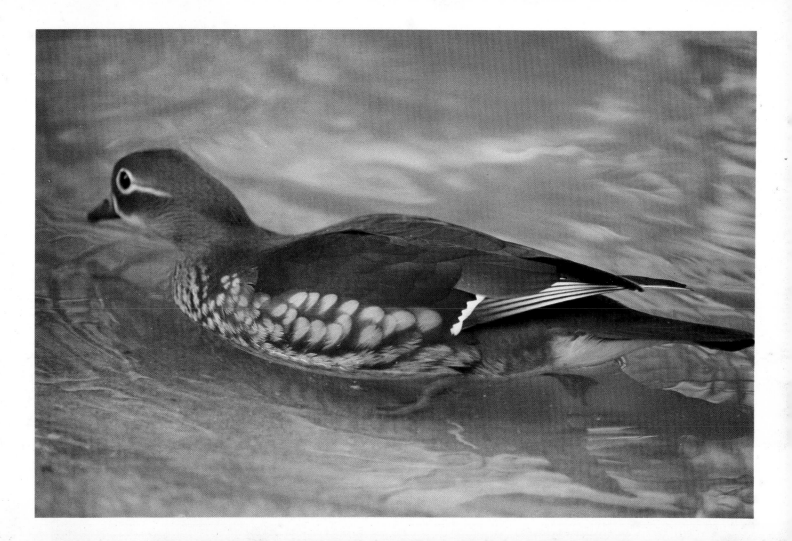

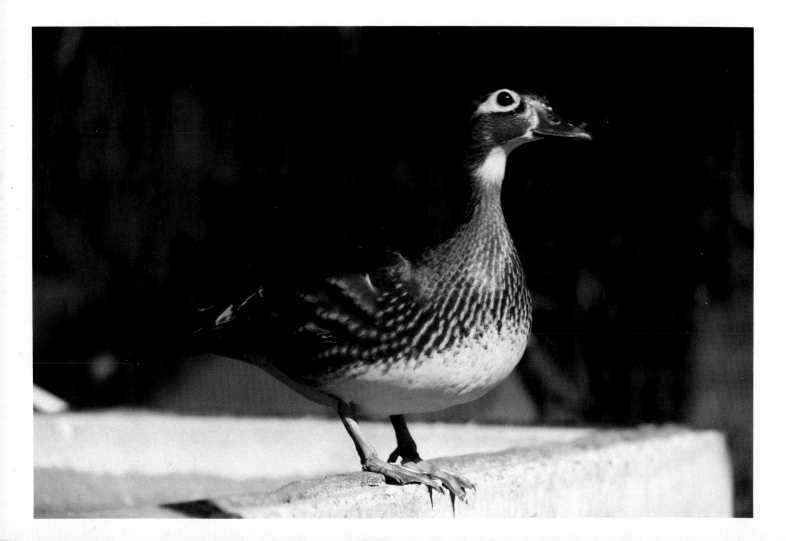

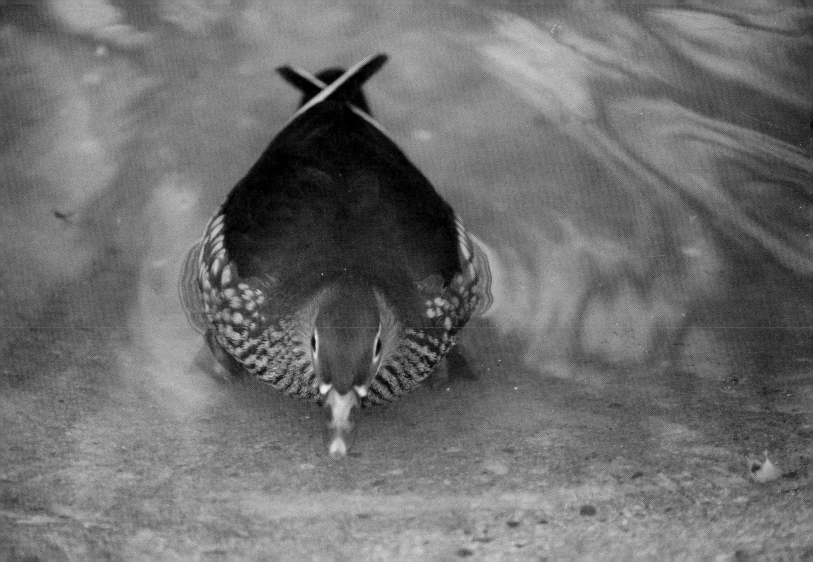

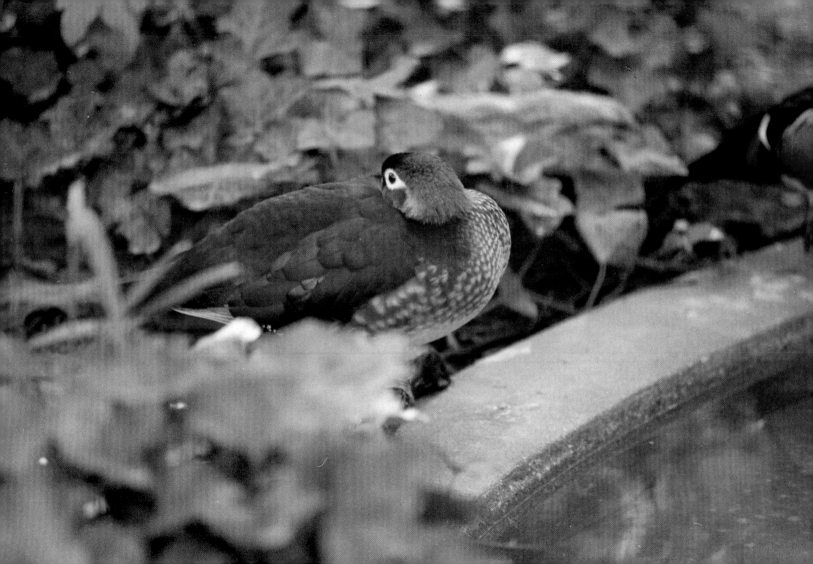

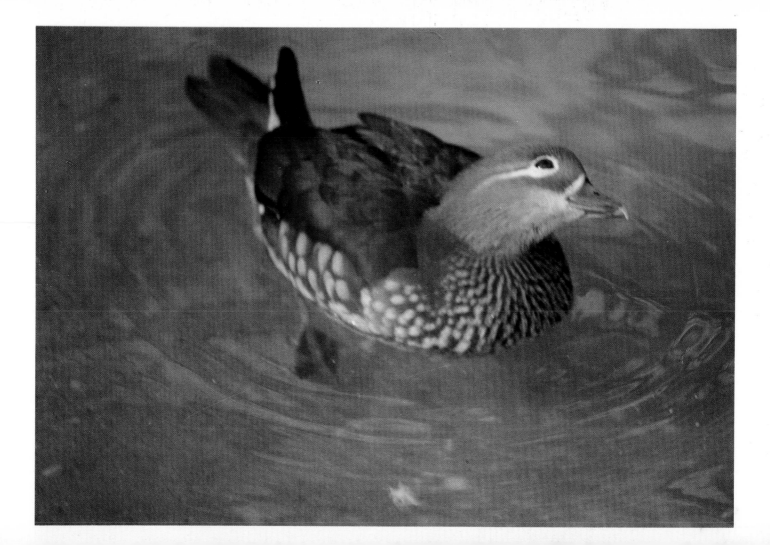

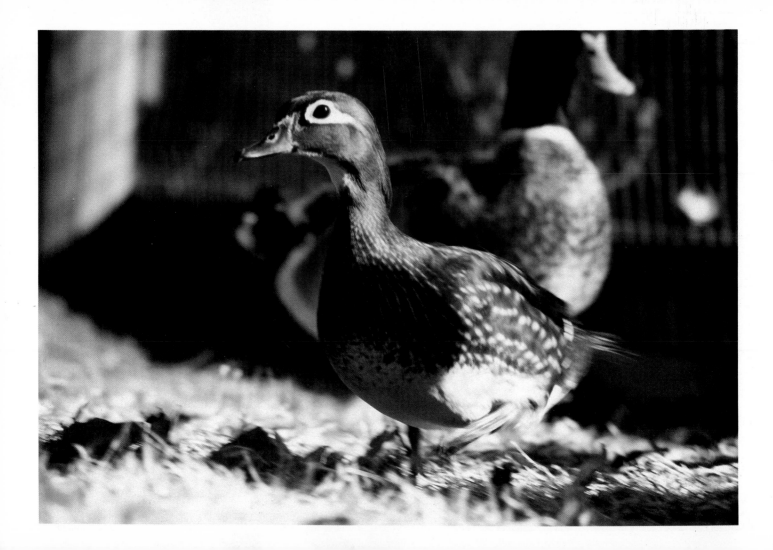

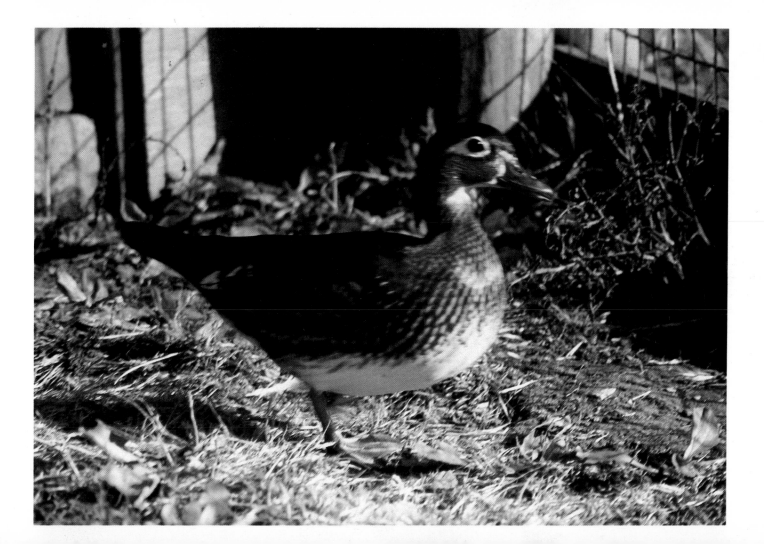

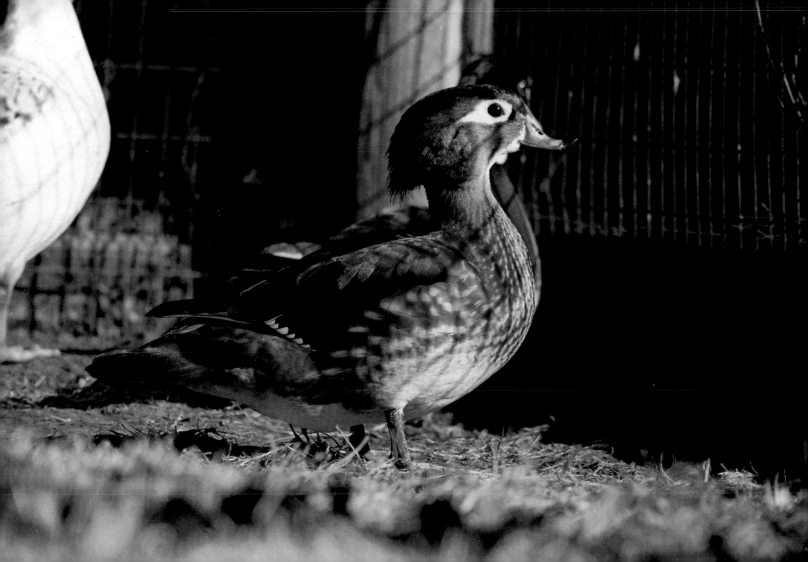

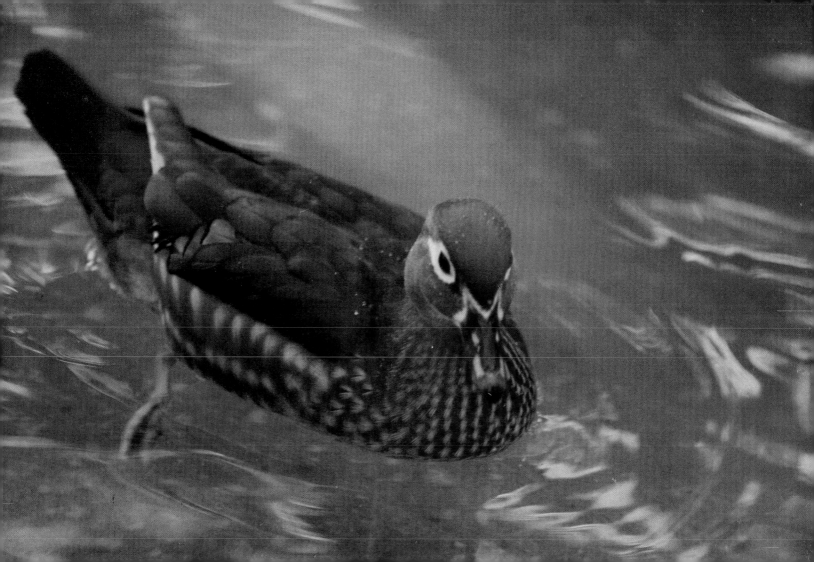

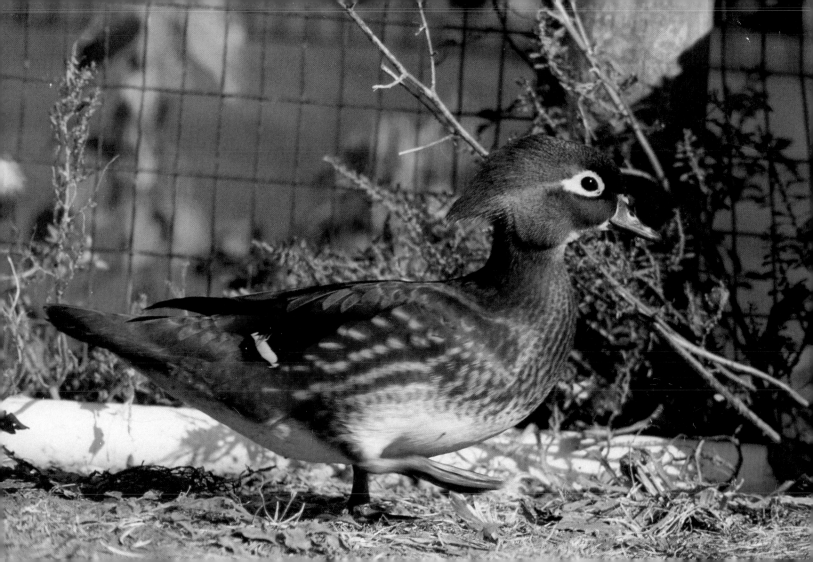

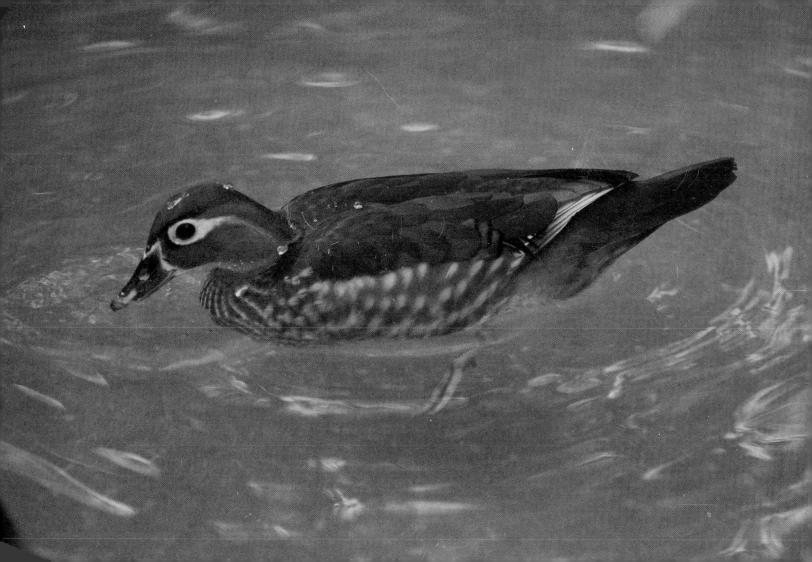

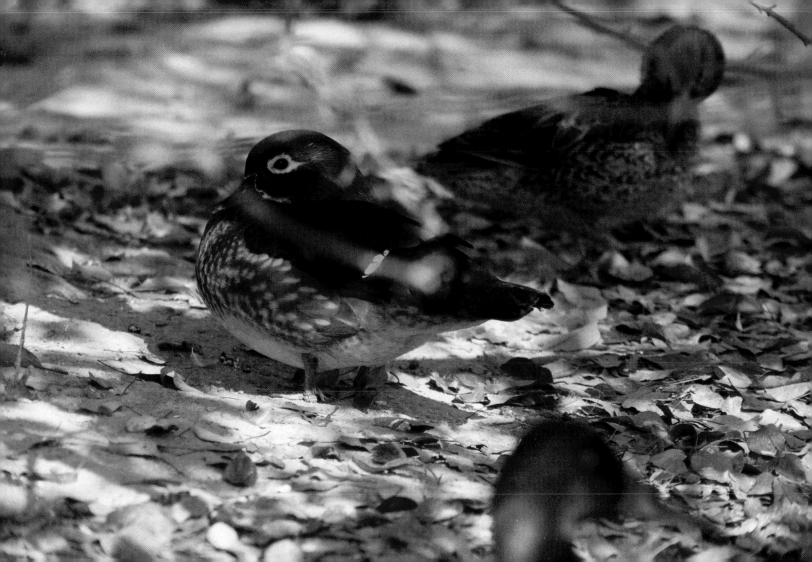

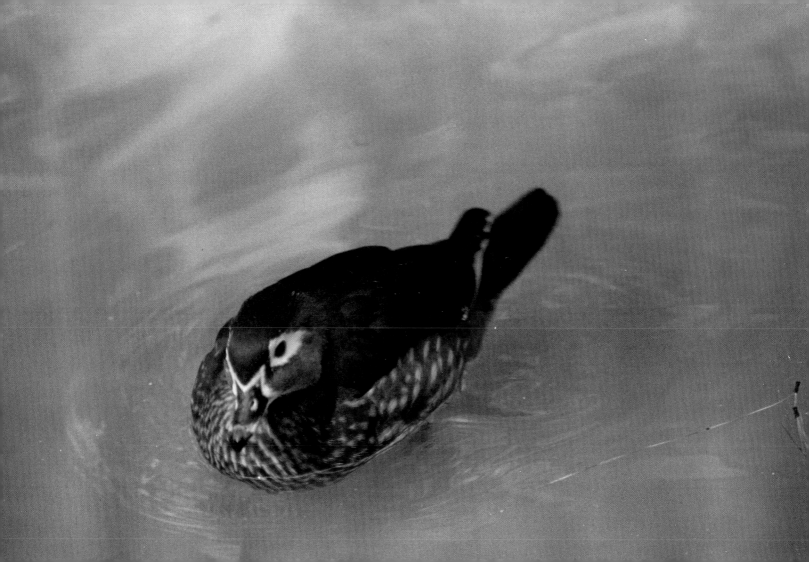

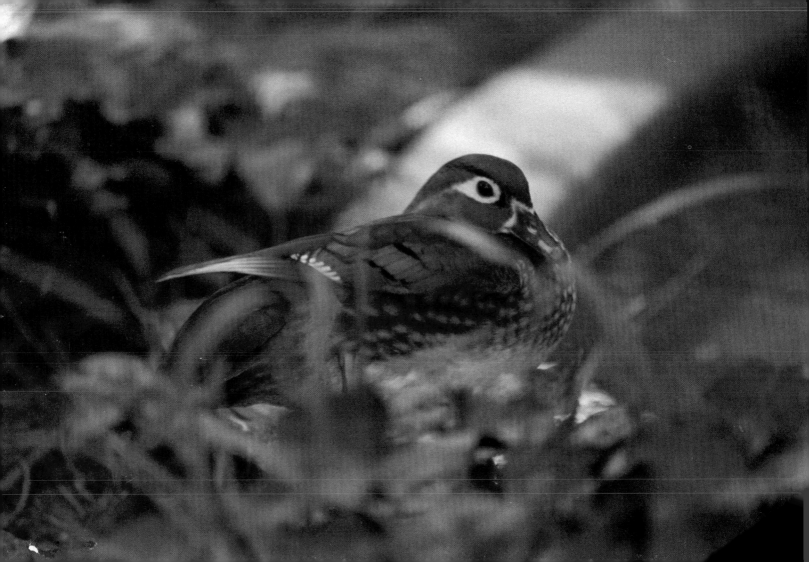

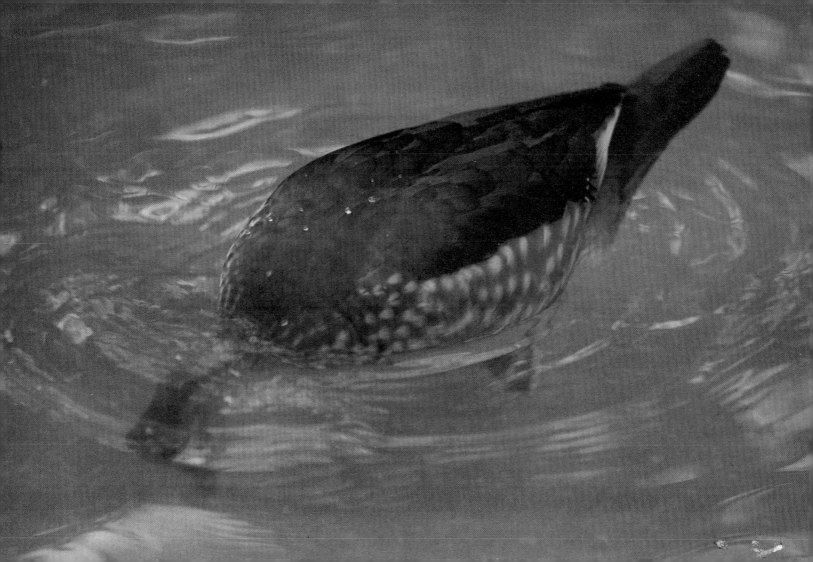

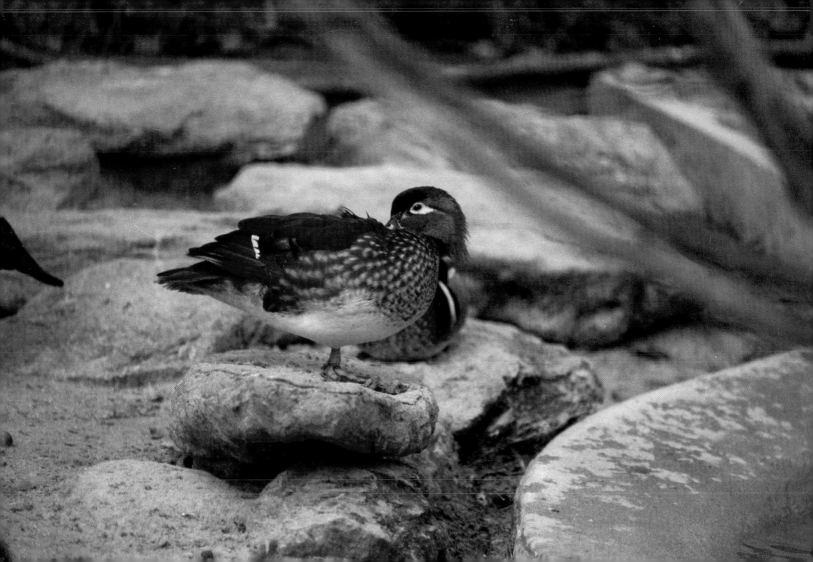

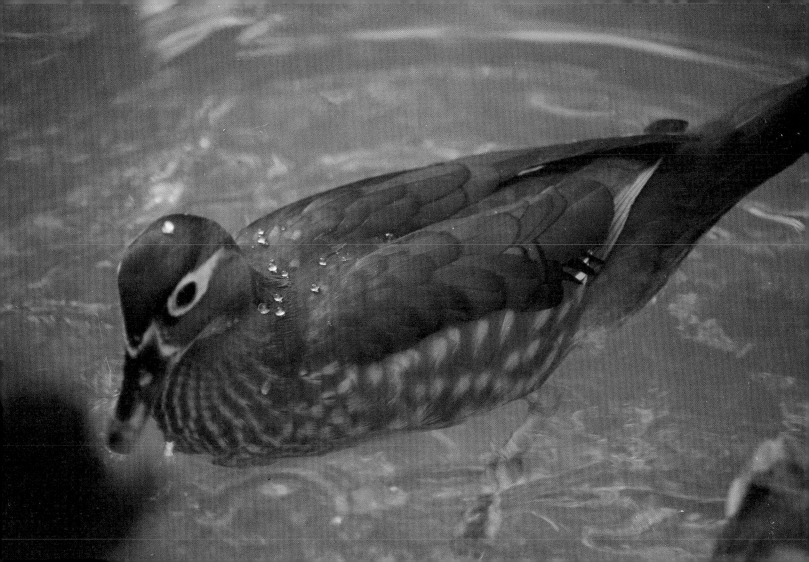

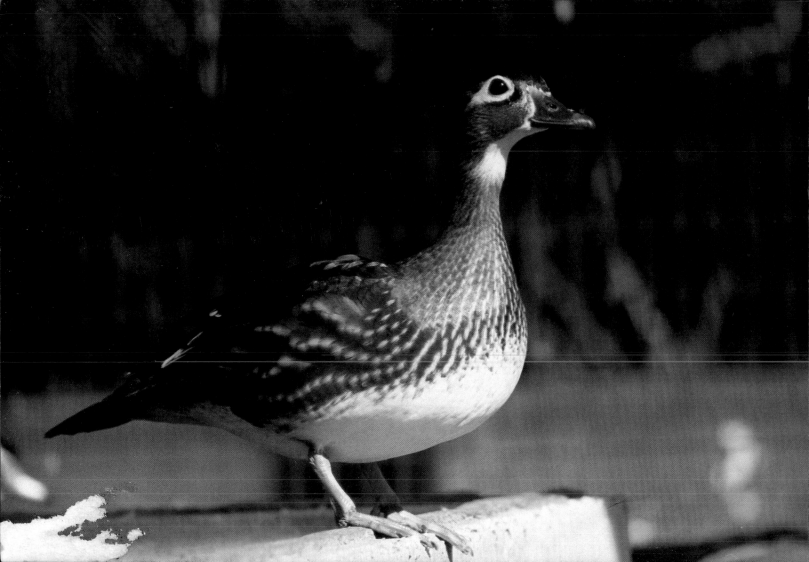

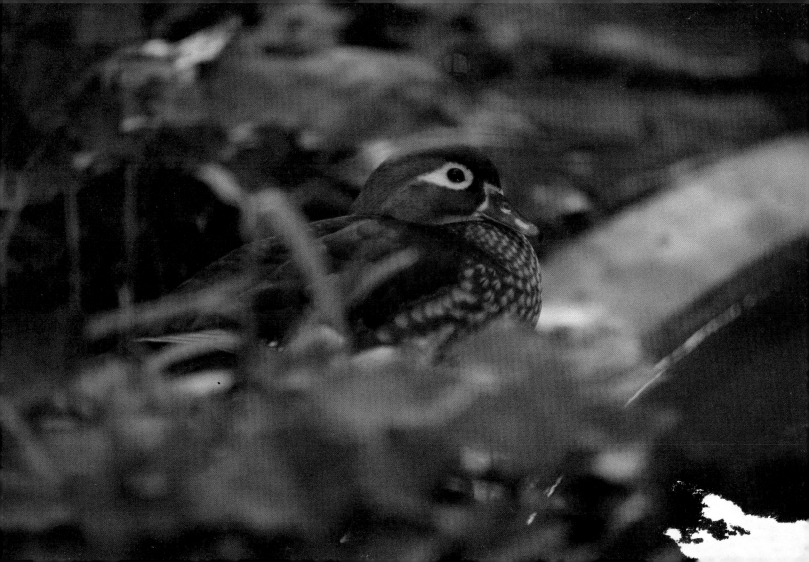

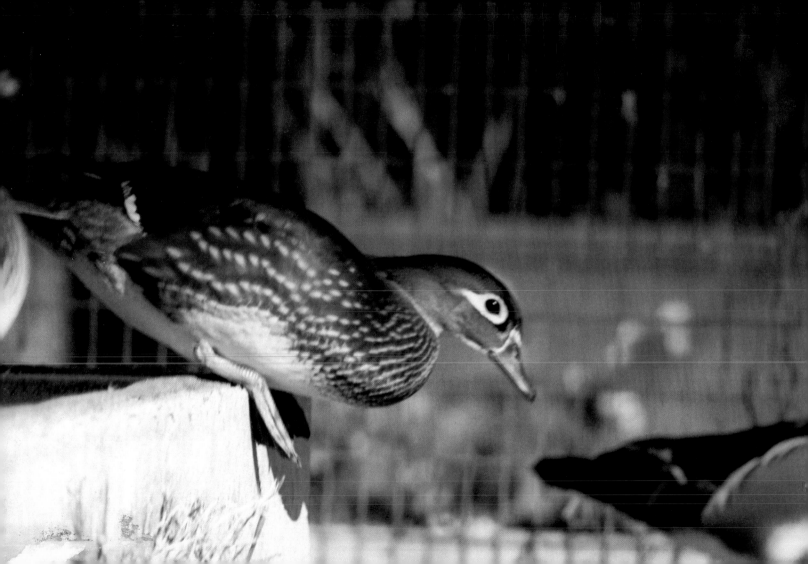

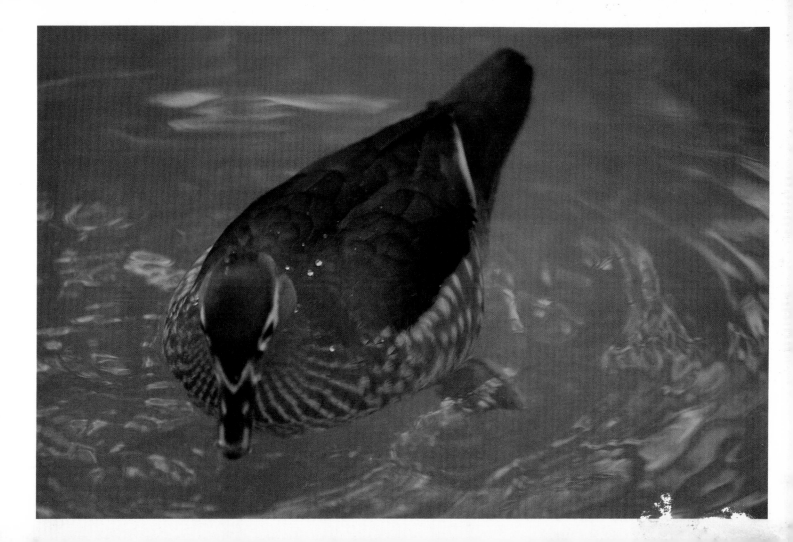

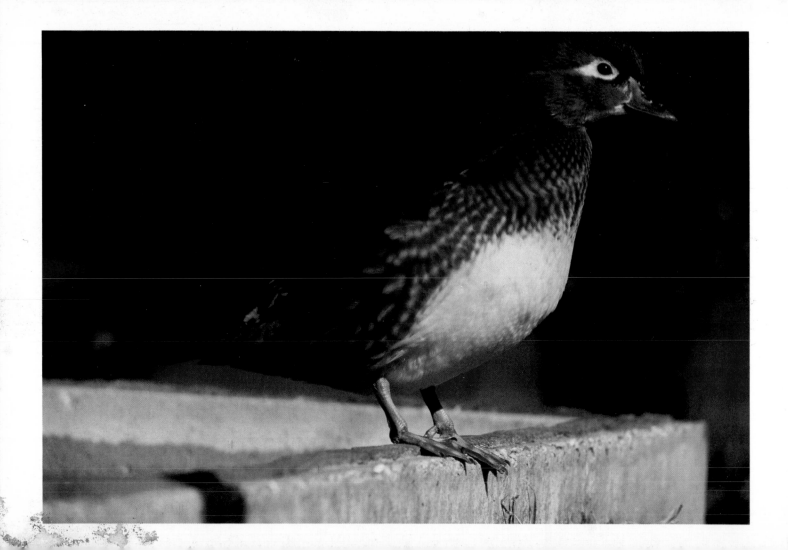

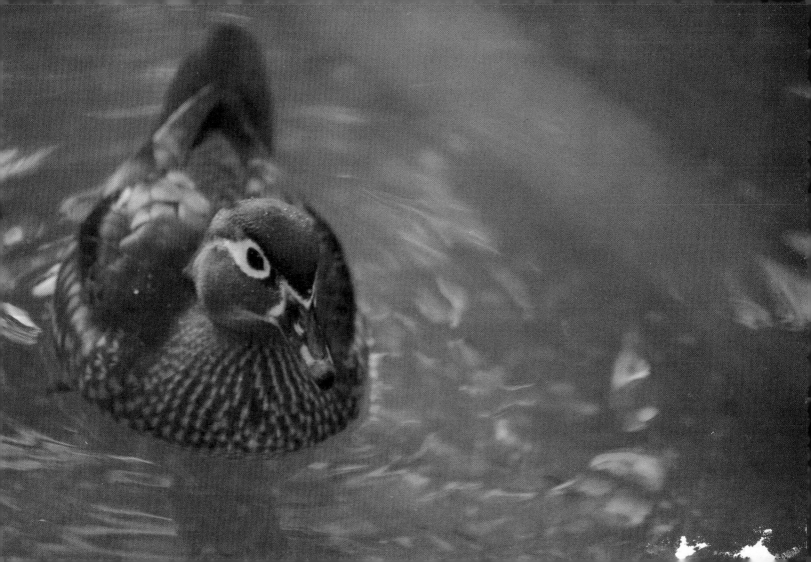

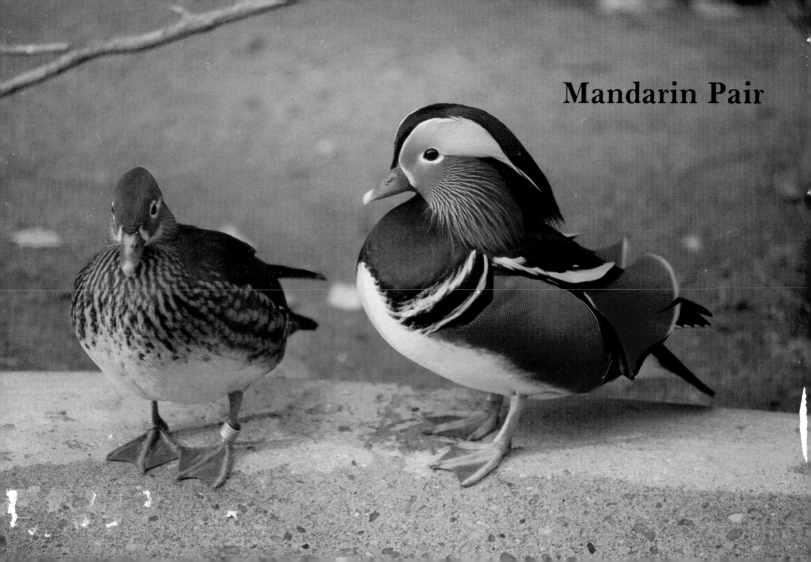

Mandarin Pair